Innocence and Experience

Images of Children in British Art from 1600 to the Present

Sara Holdsworth
Joan Crossley
with an essay by Christina Hardyment

Published in conjunction with the exhibition

Innocence and Experience

Images of Children in British Art from 1600 to the Present

19 September – 15 November 1992

Exhibition originated by Manchester City Art Galleries and toured by the South Bank Centre

Exhibition Tour

Ferens Art Gallery, Hull 21 November 1992 – 10 January 1993
Castle Museum, Nottingham 16 January – 28 February 1993
Kelvingrove Art Gallery and Museum, Glasgow 6 March – 25 April 1993

Exhibition selected by Sara Holdsworth and Joan Crossley
Exhibition administration by Ann Jones and Sara Holdsworth, assisted by
Leigh Markopoulos

Catalogue designed by Chrissy Morgan
Printed by Pale Green Press
ISBN 0 901673 00 5
© 1992 Manchester City Art Galleries

Foreword and Acknowledgements

There have been exhibitions before on the theme of children. This one aims to be different. Instead of celebrating unquestioningly the pretty and sentimental nature of the images, it raises issues such as the child's relationship to its parents and to authority, the way adults have seen play as preparation for the adult world and the use of children not only as symbols of innocence but of transience and loss. It also asks questions about today's most taboo subjects – the portrayal of child or adolescent sexuality, and the child and death. In arranging the exhibition thematically rather than chronologically the aim is to provide thought-provoking parallels and contrasts between works from the seventeenth century to the present day.

Sara Holdsworth and Joan Crossley have selected the exhibition and written the catalogue and I should like to express my warmest appreciation of their work. Many people have helped with the organisation of the exhibition and I wish to thank the staff of Manchester City Art Galleries and South Bank Touring Exhibitions for their advice and assistance, in particular Howard Smith, Ann Jones, Helen Luckett and Leigh Marko-poulos. Thanks are also due to Christina Hardyment whose essay on the history of childhood is a significant contribution to the catalogue.

We are delighted to collaborate with the South Bank Centre in creating this exhibition and I should like to thank Joanna Drew for making this possible. I am very pleased that the exhibition is being toured by the South Bank and that it is the first regional exhibition to benefit from BT's generous sponsorship of the National Touring Exhibition Service. The Paul Mellon Centre for Studies in British Art has kindly contributed towards the production of the catalogue and I am grateful to Professor Michael Kitson for the interest he has shown in the project.

I am indebted to all the artists, private lenders and directors and staff of lending galleries and museums for their generosity and time spent answering queries, also the many individuals with whom the organisers discussed the project and who contributed suggestions for the exhibition and the catalogue. In particular I would like to thank: Jon Astbury; the staff of the John Johnson and Opie Collections, Bodleian Library; Ann Bukantas; Christopher Christie; Jennifer Cox; Dennis Creffield; Paul Crossley; Diana Donald; Judy Egerton; Kathryn Ensall; Catherine Elwes; Terry Friedman; Anne Goodchild; Halina Graham; Richard Green; Robin Hamlyn; Kate Harris; Michael Harrison; Alex Hidalgo; Roger Holdsworth; James Holloway; Ghislaine Howard; Michael Howard; Sarah Hyde; Ludmilla Jordanova; Philip Lloyd; James Lomax; David Mannings; Edward Morris; Anthony Mould; Cordelia Oliver; Ron Parkinson; Morris Pearl; David Phillips; Marcia Pointon; Benedict Read; Paula Rego; Pamela Robertson; Malcolm Rogers; Joseph Sharples; Alastair Smart; Chris Stevens; Timothy Stevens; Hugh Stevenson; James Steward; Robin Vousden; Jane Wallis; Neil Walker; Marina Warner; Carel Weight; Shearer West; Bill Woodrow; Alison Yarrington,

Richard Gray
Director, Manchester City Art Galleries

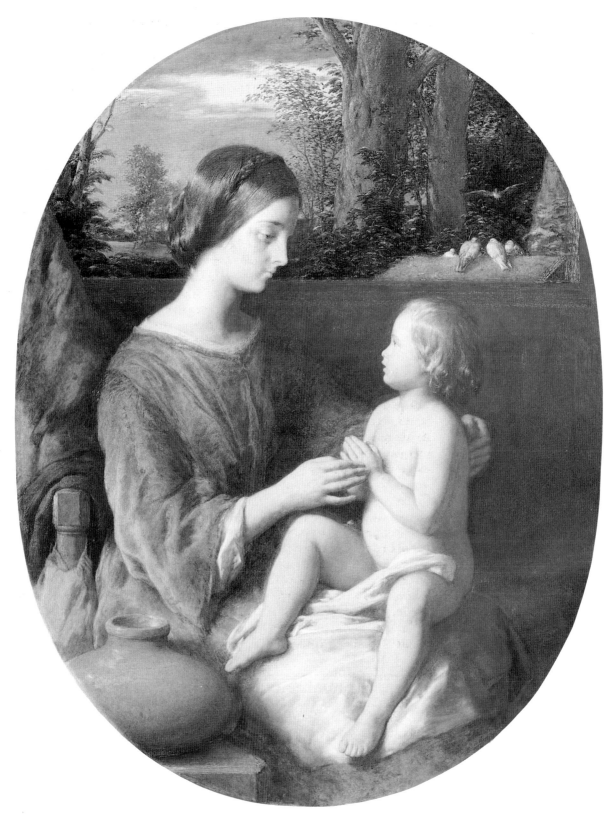

William Mulready
The Lesson 1859
The Board of Trustees of the Victoria and
Albert Museum

4

Introduction

This exhibition brings together sixty-eight works spanning four centuries of British art. Our arrangement of them is unchronological. By juxtaposing images of children from very different periods we hope that the resulting contrasts and connections will throw new light on the representation of childhood. The selection aims to be as wide-ranging as possible; we have tried to balance the historical and the modern, the familiar and the little-known, and works by male and female artists.

Paradoxically, this is an exhibition as much about adults as children. All the images of children here were made by adults and necessarily embody adult attitudes. Of course, every adult was once a child, and some artists have tried to recover the essence of that experience. Others see childhood very much from an adult perspective and their work measures the distance between their present state and their lost past.

The exhibition is divided into four sections, and the essays in the catalogue follow this structure. The first, *The Family*, deals with the relationship of children to their parents, both mothers and fathers, and traces the powerful social and psychological dynamics of the family which mould images of both happy and unhappy family life. *A Sense of Identity* focuses on child portraiture; it considers how representations of the child as an individual entail assumptions about the acquisition of sexual, cultural and social identity. *Work and Play* examines the broad range of images of children at play, with the aim of demonstrating that what appear to be depictions of self-involved, pre-adult worlds actually reflect adult concerns. This section also looks at the child's induction into the rigours and responsibilities of adulthood through school and work. In the final section, *The End of Innocence*, we consider the ways in which children have been used as symbols, not only of innocence but of the transience of life. This part of the exhibition also deals with images of the death of children and the long history of representations of child and adolescent sexuality.

This is an exhibition about the history of images of childhood rather than the history of children themselves. The essays and entries in the catalogue attempt, nevertheless, to interpret the images which the exhibition assembles in the light of the stimulating research into the altering conditions of childhood experience, psychological, social, and economic, which has been undertaken during the past twenty years. To assist this task, Christina Hardyment explores the historiography and history of the subject, and her survey of the changing lives of British children from the seventeenth century to the present gives solid ground and perspective to the discussions of the paintings.

It is an appropriate moment to be reconsidering the representation of children. The profusion of new books and television documentaries and the amount of press attention suggest that the concept of childhood is of greater interest than ever before. There is heated debate about education, job-training, parental discipline and punishment, sexuality, and the age of consent. These issues are not contemporary discoveries; as we have tried to show, they are rooted in the history of childhood and reflected in the way children have been depicted by artists.

Sara Holdsworth
Joan Crossley

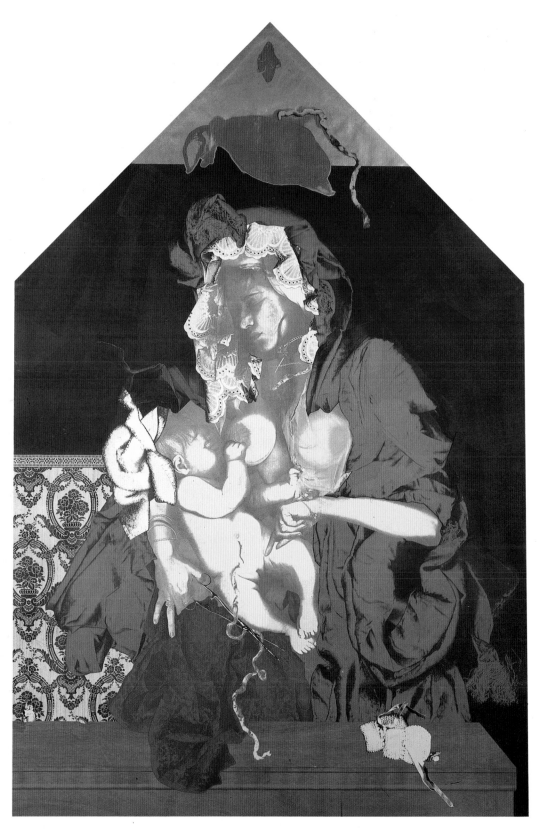

Helen Chadwick
One Flesh 1985
The Board of Trustees of the Victoria and
Albert Museum

6 The Family

The Family

Sara Holdsworth

The Maternal Bond

A mother and her baby – the most fundamental of family relationships – conjures up for us an image of transparent simplicity and naturalness. But behind this apparent simplicity lies the complex history of the image of the Virgin and Christ Child. In Medieval and Renaissance art the Virgin is a repository of cultural and social attitudes towards women: images of her range from Queen of Heaven to humble peasant. But in her central role as idealised mother the qualities conventionally emphasised are tenderness, submissiveness and serenity.

The power of the Virgin and Child image is evident from its use as a point of reference by later artists. In Victorian England William Mulready was able to employ it in this way to create an icon of the value of maternal influence on a child's moral and spiritual welfare. *The Lesson*, 1859 (cat.1, illus. p.4), aims deliberately at religious resonances: the mother has the calm face and downcast eyes of a Raphael Madonna and the doves and the nakedness of the child suggest depictions of baby Jesus rather than an intimate domestic scene of the 1850s. As with Bellini's Madonnas the slight distance between the two figures emphasises the importance of the child. While showing the mother's key role as teacher, Mulready makes the point that, essentially, she remains a vessel, indicated by the clay pot at her side. The idyllic landscape behind them is a conscious reminiscence of fifteenth-century Italian art. Nature and nurture come seamlessly together in an atmosphere of untroubled piety. The quotation with which the painting was exhibited, 'Just as the twig is bent, the Tree's inclined', points up the connection.

The slightly sickly mid-Victorian religiosity of this late work by Mulready marks a change of emphasis from his earlier interest in Godwin's radical educational theories about the child's learning from social example (see *Train up a Child*, cat.45). The sentimentality is obvious when one compares William Blake's frontispiece to *Songs of Innocence*, 1789 (cat.51, illus. p.96). Here a sinuous apple tree and vine reach out menacingly to the children learning to read at their mother's knee, a striking image which makes the relationship of nature and nurture a far more problematic matter.

In the late twentieth century, as Julia Kristeva has pointed out, the demise of the cult of the Virgin, has left us without a satisfactory discourse on motherhood. Recent feminist artists have been concerned with just this problem: how to depict anew the relationship in a way that can express 'the anguish, the suffering and the hopes of mothers'.[1] Helen Chadwick's *One Flesh*, 1985 (cat.2), takes up Kristeva's argument and creates a new meaning for the Virgin and Child. Not only is the baby a girl and the cloak blood red, but the picture stresses, with its placenta and umbilical cord, the biological facts of childbirth that are denied in traditional representations. The title *One Flesh* refers not to the sexual union between man and woman, but to the deeper bond, that between mother and child, and more specifically, between mother and daughter. But despite the work's insistence on physicality it is a deliberately contrived image, both in its technique and in its use of pose, gesture and symbol.

This perception of the mother-child relationship as a cultural construct rather than a natural experience has been an important element in many feminist works of the last twenty years. In particular, Mary Kelly's well-known *Post-Partum Document* (1973–9) portrays her relationship with her young son by deliberately excluding any image of the artist with her child. Instead, it consists of material things such as nappy liners, baby vests, and hand prints as well as a series of slate and resin slabs (deliberately reminiscent of the Rosetta Stone) on which are inscribed a complex record of the child's acquisition of language. His gradual withdrawal from his mother and induction into the new social world of nursery school and paternal authority are seen in the piece in terms of Lacanian psychoanalytic theory. On each slab the child's comments are juxtaposed with a diary of events. The two 'documents' are deliberately left as discrete entities making motherhood a creatively unfixed and unresolved process.

Catherine Elwes, a video artist whose subject has likewise been the exploration of her

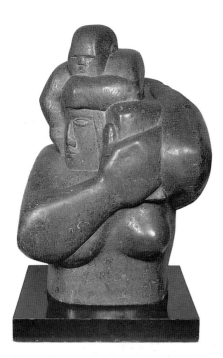

Henry Moore
Mother and Child 1925
Manchester City Art Galleries

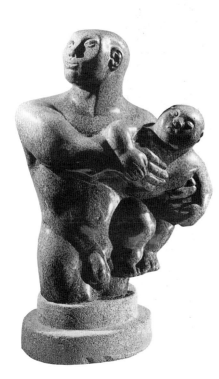

Maurice Lambert
Father and Son 1931-2
Leeds City Art Galleries

relationship with her son, is also wary of final conclusions. She has written 'I find myself exploring contradictions and ambiguities. I accept inconsistencies and draw freely on the mixed emotions of motherhood'.[2] She avoids her son's speech, habits and idiosyncracies in order to avoid exploiting him. Instead, she hopes to create 'a phenomenon, a force that elicits a multitude of confused responses from his mother whose own identity remains the central theme of each tape'.

Feminist works such as these avoid any simple expression of the mother-baby relationship as natural and complete. The traditional view was perhaps adopted most strongly in the work of Henry Moore and Eric Gill who treated the mother and child theme throughout their careers. In Moore's *Mother and Child*, 1925 (cat.3), the point is made by the tightly interlocking limbs and impassive faces as if, as Peter Fuller has pointed out, Moore wished to depict the relationship from the child's point of view as a fusion between mother and baby which is part of the experience of early infancy. Moore's stress on close physical contact between a child and its mother is the more striking if we compare Maurice Lambert's *Father and Son* (1931–2, Leeds City Art Galleries) where, instead of Moore's stillness and containment there is an Oedipal struggle as the boy pulls free of his father's grip.

The inwardness of Moore's mother and child is connected to his desire to go back to what he thought of as the primitive archetypal earth mothers of ancient Mexican and African carving. The influence of ancient art, the rockiness of the forms and the almost animal way the child sits on its mother's shoulders, all express the timelessness and naturalness of the relationship. Similarly, Gill's breastfeeding *Mother and Child* (1910, National Museum of Wales, Cardiff) was praised by Roger Fry for its 'animalism'; he had 'looked directly at the real thing'.[3] Such an analogy may have been suggested by theories of child-raising current in the early years of this century which continually treated the child as part of the process of evolution. Many writers made connections between children and animals, influenced perhaps by the work of early behaviorists, such as Pavlov and Watson. Others saw the infant stage as similar to that of primitive man, and the child as climbing up the evolutionary ladder to reach adulthood.

Recent depictions of earth mother figures focus on different qualities from those discovered by Moore and Gill. Eileen Cooper's paintings and drawings celebrate the mother as the active and creative principle in the natural world, digging, planting, nurturing and at one with plants and animals. But this Garden of Eden is not without its difficulties. In *The New Baby*, 1988 (cat.4), the mother has an expression of wide-eyed anxiety as she cradles her baby, while an older child looks on in envious exclusion. Similarly, *Play Dead*, 1991 (cat.30), dramatises the mother's sense of being overtaken and left behind by the growing child who dwarfs her, so that she is now marginalised herself. Peter Howson's extraordinary image of a mother leading her children into the sea in *Blind Leading the Blind I*, 1991 (cat.62), shocks us by melodramatically reversing the idea of the protective, nurturing mother. It is poignantly unclear whether the dangers that she is running both from and into represent social or psychological forces.

Such self-conscious anxieties of relationship belong to the post-Freudian world. In the eighteenth century maternal affection was viewed less problematically as part of the essentially feminine qualities of virtue and sensibility. In 1693 Locke's *Some Thoughts Concerning Education* had emphasised how much the parent was responsible for the development of the child. Rousseau's *Emile*, translated into English in 1763, stressed the role of Nature by means of analogies of upbringing from the animal world. Rousseau urged mothers to breastfeed their own children in order to establish bonds of natural affection between them, rather than send them out to wet nurses. It was believed that a child might take on the qualities of the woman who suckled it, and anxiety was widespread about the contagion of lower-class habits if a child was fed by a wet nurse. By the 1780s a visitor to England noted 'Even women of quality nurse their children'.[4] The practice of swaddling small babies was abandoned at this period; contemporary child care manual writers, following Rousseau, urged mothers to allow their babies to kick

Eileen Cooper
The New Baby 1988
Benjamin Rhodes Gallery

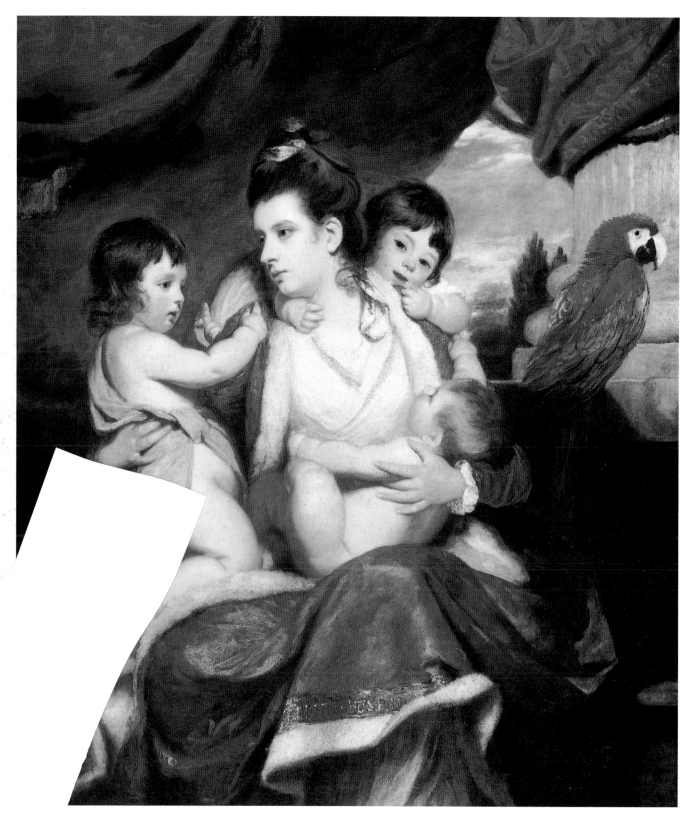

Sir Joshua Reynolds
Lady Cockburn and her Three Eldest Sons 1773
Trustees of the National Gallery

10 The Family

freely on the floor.[5]

From the 1760s mother love became the dominant theme in paintings of upper-class mothers with their children. Jean-Baptiste Greuze's *La Mère bien Aimée* (*c.*1769) shows the Marquis de Laborde, a wealthy financier who commissioned the picture, returning from a hunt to find his wife bare breasted and ecstatically drowning in a tidal wave of babies. Reynolds' *Lady Cockburn and her Children* (1773, National Gallery), although a little more restrained, has the same theme of adoring motherhood. The youngest baby is shown in a suckling position (although for modesty Lady Cockburn's breast is covered). The children who cling playfully onto their mother may derive from allegorical depictions of Charity, but the main impression is of a self-involved family group. In *Georgiana, Duchess of Devonshire with her Daughter* (Devonshire Collection,

Sir Joshua Reynolds
Georgiana, Duchess of Devonshire
*c.*1784
Devonshire Collection, Chatsworth, reproduced by permission of the Chatsworth Trustees

Chatsworth), painted a few years later, Reynolds shows the Duchess caught up in a moment of joyous sympathy with her baby daughter as they mirror one another's gesture. Georgiana breastfed her children, and the shared movement suggests that the little girl will grow up to be just like her mother.

Compared to these sprightly mothers and babies many nineteenth-century pictures have an air of passivity. This may be due to the ever-increasing importance given in the early years of the century to the maternal character and its influence over the child. Mothers at this period were thought to be responsible for the moral and religious education of their children and were, accordingly, advised against excessive novel reading, violent emotions and physical fatigue.[6] Mulready's *The Lesson*, 1859 (cat.1), discussed earlier, draws self-consciously on the image of the Virgin and Child to make a point about maternal quietitude and protectiveness. A later example, Thomas Gotch's *Holy Motherhood* (1902, Laing Art Gallery), also reworks religious imagery to create a hierarchy of angelic young women, with the mother, eyes modestly lowered, at the top

W.Q. Orchardson
Her Idol 1868-70
Manchester City Art Galleries

and the younger girls waiting patiently beneath for their destiny.

The nineteenth-century cult of the mother is dramatised in a secular way by W.Q. Orchardson in *Her Idol* (cat.5) of 1868–70 where an 'attenuated, fever-smitten Scottish matron', as one critic called her,[7] is idolising her little doll-like girl who is in turn preparing for her adult role by idolising her doll. The mild joke suggests perhaps a measure of ironic distance. More mundane mid-Victorian examples of quietly saint-like mothers abound. Artists like G.E. Hicks and George Smith, as well as those of the Cranbrook Colony, often painted mothers gazing fondly at their sleeping babies or engaged in domestic tasks. The setting tends to be middle or working-class rather than aristocratic, reflecting the influence of Dutch genre paintings with their dim cottage interiors and crib scenes. Social realist artists like Frank Holl concentrated on maternal care and grief in paintings such as *Hush!* and *Hushed* (1877, Tate Gallery), and *Her First Born* (1877, Sheffield City Art Galleries), which show the illness, death and funeral of a small child in poverty-stricken surroundings.

The self-sacrificing mother in a humble setting is brought into the twentieth century by Dame Laura Knight's paintings of domestic scenes set in the Yorkshire fishing village of Staithes. In both *Dressing the Children*, c.1906 (cat.6, illus. p.19), and *The Knitting*

Lesson (Harris Museum and Art Gallery), the mother's face is in shadow or obscured, suggesting her selfless role. A miserably poor mining family who did not have enough money for rent, food and clothes were paid to pose for *Dressing the Children*. The picture, however, is not about their poverty; it is a celebration of working-class domestic values, simple but warm.

The working-class mother and child theme was taken up for the last time as a paintable subject by the 'Kitchen Sink' school of the 1950s. (From the 1920s the topic had been seen as one belonging more to documentary photography). In Jack Smith's *Mother bathing Child* (1953, Tate Gallery), and Leslie Duxbury's *Tenement Dwellers* (Arts Council Collection), mothers impassively care for their children in alienating monochrome surroundings. The deliberately detached quality of these works provides a striking contrast to nineteenth-century sentiment and maternal cosiness.

Fatherhood

There is no male visual equivalent to the powerful and complex Christian tradition of mother and child iconography. Instead, depictions of fathers and children centre on the secular here and now of the family portrait. But this is not to suggest that there is no history of depicting paternal authority. Patriarchal values, whether enforced or undermined, are central to the image of the family group from the sixteenth century to the present.

Analogies between the king as father of his people and the rule of a father over his family were often made by Royalists in the seventeenth century, a period in England both of strong authoritarian state control and rebellion against it. When in 1649 Arthur, Lord Capel was tried and executed for leading an unsuccessful royal rebellion, he defended himself by citing the Fifth Commandment, 'Honour thy Father and Mother', and arguing that he was acting in defence of the nation's father.[8] Cornelius Johnson's painting of him, *c.*1640 (cat.10, illus. p.20), makes his position as head of the family clear. Lord Capel (and his sons, including the baby) all face the viewer directly. His wife looks deferentially towards him and his youngest daughter hands a flower to her baby brother. As Jonathan Goldberg points out, the importance of the male line is underlined by the way that Lord Capel's hat sits on a table just above his son's head and mirrors the boy's own headgear.[9] The architectural background behind the male half of the portrait and the garden behind the female half make clear the traditional culture/nature split between man and woman.

Numerous paintings of the period show a similar interest in the authority of the father and the handing on of power through the male line. Often the poses of father and son mirror each other or the father gestures towards or touches his son. The persistence of this tradition can be seen as late as Zoffany's *Sir Lawrence Dundas and Grandson* (1769–70, Marquess of Zetland), where the grandfather sits with the child by his side. The couple are almost overwhelmed by the splendour of his collection of paintings and sculpture which will one day be the small boy's property.

However, such formal displays of paternal power do not necessarily mean that relationships between fathers and children were always strained. Ideological images need not reflect the actuality of family life. Accounts of affectionate relationships between fathers and their children are numerous, particularly in the late seventeenth and eighteenth centuries. For example, John the future Duke of Marlborough wrote to Sarah, his wife, in the late 1680s: 'You cannot imagine how pleased I am with the children, for they having nobody but the maid, they are so fond of me that when I am at home they will always be with me, kissing and hugging me'.[10]

Domesticated fathers appear first in Dutch art of the seventeenth century, where they are portrayed as absorbed within the home circle. Simon Schama notes Van Ostade's many images of a peasant father spoon feeding his child, and one engraving which even

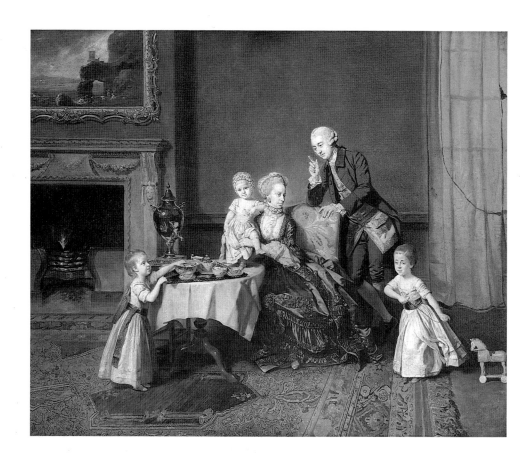

Johann Zoffany
*John, Lord Willoughby de Broke and
his Family* 1766
Courtesy Christie's

Ford Madox Brown
Take Your Son, Sir 1851, 1856-7
Tate Gallery

shows a man walking up and down with his baby at night to send it to sleep.[11] British scenes are less intimate, but by the eighteenth century artists like Zoffany were creating images of fond aristocratic fathers emotionally involved with their families. However, even in one of his most relaxed examples, a portrait of *John, Lord Willoughby de Broke and his Family* (1766), the father is shown as looking down over the group and admonishing (although good humouredly) his small son who is helping himself to a piece of bread from the tea table. A similar point is made by William Hoare's unusual portrait of a father and daughter, *c*.1779 (cat.7, illus. p.23). Here, a young girl tries unsuccessfully to distract her father with her doll from the letter he is writing. As in the Zoffany, affectionate intimacy is held in unresolved tension with masculine detachment and independence.

A century later, Ford Madox Brown explored the issue of paternity in an enigmatically symbolic way in *Take your Son, Sir* (1851, 1856–7, Tate Gallery). A Madonna-like woman holds out a naked baby to a man who is visible only in the mirror that haloes the mother's head. The painting has been read as showing a kept woman (a haloed Magdalen) challenging the father to acknowledge his relationship with their bastard.[12] Another more straightforward interpretation, which perhaps fits better with the fact that the man is smiling and that Brown used himself, his wife Emma and baby son Arthur as models, is that the picture marks symbolically the future handing over of the son from maternal to paternal ownership. If one understands the picture in this way, its title takes on a celebratory rather than an accusatory force. It becomes an expression of proud fatherhood rather than the icon of maternity which it at first appears. The title of another work by Brown, *Waiting: an English Fireside of 1854–5* (Walker Art Gallery, Liverpool), in which a mother sews by the fire with her baby asleep in her lap, also implies that the father is the temporarily missing element needed to complete a picture of perfect domestic bliss.

Other Victorian artists give a privileged position to fatherhood. In Frith's picture of an idyllic family group, *Many Happy Returns of the Day* (cat.11) of 1856, the father is placed at the head of the table. In an early study he looks towards the grandmother who is seated on the right, but she was later replaced by a grandfather, which throws the emphasis, as in seventeenth-century portraits, onto the male line.

Children who chafe against paternal authority have a long literary ancestry, from Icarus to Hamlet and Paul Morel in *Sons and Lovers*. In real life, conflicts were often of an economic as well as an emotional kind. Sons and daughters depended on inheritances to establish themselves in the world and on their parents' willingness to provide the means to enable them to marry. There was debate in the seventeenth century about when paternal authority over children ceased; Locke was unusual in declaring offspring over the age of majority as being released from unquestioning obedience. That such matters do not appear in family portraits is hardly surprising, as such works inevitably celebrate unity rather than division. On the rare occasions when conflicts are investigated it is in a symbolic way. William Blake, for example, had a deeply ambivalent attitude to male authority. Sometimes he imagines father figures as benificent creators. More often his sympathy is with the child, as in 'Infant Sorrow' where a newborn baby describes himself as:

> Struggling in my father's hands
> Striving against my swaddling bands:
> Bound and weary I thought best
> To sulk upon my mother's breast.

Here, the father stands for the powerful forces of emotional and social repression that Blake saw as corrupting proper human relationships.

The idea of a struggle between father and children is taken up by Paula Rego, in whose paintings of the family male authority is undermined by female manipulation. Prim girls devote themselves to polishing their father's boots or combing their brother's hair with a strangely sinister intensity. In *The Family*, 1988 (cat.15, illus. p.24), two inscrutable daughters may be engaged in simply dressing their father who lies helpless against the bed, or, as his expression suggests, they may be torturing or sexually abusing him. The physical and sexual domination of a father by his children shocks us particularly because it combines the taboo of incest with its even more powerful opposite: the taboo of female revenge against patriarchy.

The stern and unloving *paterfamilias* of Victorian literature, Dickens' Gradgrind and Murdstone or the repressive Evangelist father of Samuel Butler's *The Way of All Flesh,* is missing from Victorian art. Instead, its anti-type, the nurturing father or grandfather, was a characteristic image. J.H. Henshall's *Faither an' Mither an' A'*, 1908 (cat.8), is in the tradition of Luke Fildes' *The Doctor* (1891, Tate Gallery) and *The Widower* (1903, Walker Art Gallery); all involve a similarly poignant contrast of a burly man looking after a sick but cherubic child. (Agnew's photogravure of *The Doctor* became the most popular print the firm ever published and the picture was later reproduced on two postage stamps.)[13] Writing about *The Widower, The Art Journal* pointed out that its appeal lay in 'the rough helplessness and momentary tenderness of a rugged nature'.[14] The picture acts, in other words, against our expectations of male behaviour. Indeed, reversals and inversions of mother, father and child roles are common in the period. A spate of minor pictures such as Archibald Wortley's *The Poacher's Daughter* (Usher Gallery, Lincoln) and John Lee's *Grandfather's Comfort* (c.1860, Williamson Art Gallery and Museum, Birkenhead) reflects the Victorian interest in adult men looked after and morally redeemed by children, paralleling Dickens' Little Nell who cares for her grandfather or Paul and Florence Dombey whose father is rehabilitated by them.

The 'maternal' father is an image of the twentieth century mainly in the countless family photographs showing proud fathers holding their babies. Such images of male domestication probably do not accurately reflect actual behaviour since work and family

J.H. Henshall
Faither an' Mither an' A' 1908
Ferens Art Gallery; Hull City Museums and Art Galleries

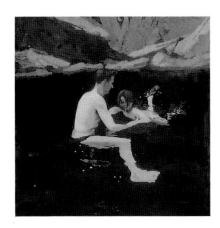

Michael Andrews
Melanie and Me Swimming 1978
Tate Gallery

Dennis Creffield
Anxious Father, Anxious Baby 1983
Arts Council Collection

roles were, especially before the 1960s, only a little less sexually differentiated than they had been in the past. A girl brought up in the 1930s recalled her father's exalted position in the household: 'I never remember my own father making so much as a cup of tea, and he had the infuriating habit of tapping his empty cup with a spoon when he wanted a second cup He would expect one of us to jump up and pour one for him'.[15]

Winifred Nicholson's 1927 portrait of her husband cradling their infant son (cat.9, illus. p.25) is a particularly tender image of a nurturing father which has the informality of a snapshot. It is, however, interesting that although Ben looks down at the baby, the child's bright blue eyes (emphasised also by the title *Starry-Eyed*) are intent on his mother who is painting him, switching the emphasis back to her. Michael Andrews' *Melanie and Me Swimming* (1978, Tate Gallery), a painting about a father's protection and education of his daughter, and Dennis Creffield's series of drawings of his baby son, particularly *Anxious Father, Anxious Baby* (1983, Arts Council Collection), are unusual in their tenderness. Male artists have not explored the complexities of the father-child relationship to the extent that feminist artists have opened up motherhood. The image of the New Man of the 1980s and 90s who changes the baby's nappies remains largely an icon of the billboard, a product of the advertiser's search for new markets.

Family Groups

Images of the family that a particular society or culture find congenial always reflect its attitudes to what belongs to the public as opposed to the private sphere. In the sixteenth and seventeenth centuries the family was not seen in opposition to society at large, and portraits convey its public status. Historians have shown that the nuclear family of mother, father and children has been established as the basic element in English society for at least six hundred years.[16] But 'family' could also mean a much wider network of kinship (as it still can today) and could also include household servants. The word's primary modern sense is still missing from Johnson's *Dictionary* in 1755.[17]

The family as wider grouping is the subject of the earliest English portraits such as that of *William Brooke, 10th Lord Cobham and his Family* (1567, Marquess of Bath, Longleat), by the Master of the Countess of Warwick, where Brooke's sister-in-law is included. A cartouche in the centre of the picture dignifies the family with comparisons to that of Jacob and Job, and the children's ages are recorded above their heads. Such formalities were appropriate in an age when aristocratic portraits were used not simply as a record of an individual's appearance but as a diplomatic tool or for marriage broking. Family paintings of this period often feature elements such as coats of arms which reveal the family's history in an emblematic way, or even such startling devices as showing dead members of the family alongside the living as in John Souch's *Sir Thomas Aston at the Deathbed of his Wife* (1635, Manchester City Art Galleries), which encapsulates his family's recent history by showing Aston's wife both alive and as a corpse.

The idea of the portrait as an instrument of public display is mirrored in the architecture of aristocratic houses of the period, where great public rooms were only just beginning to give way to smaller, private chambers and corridors which allowed access by servants without intrusion. Modes of behaviour between family members could also be formal. Even though the relationship might be a deeply affectionate and loving one, early seventeenth-century children addressed their parents as 'Sir' and 'Madam' to signal the child's subordinate position in the household. It was customary to kneel before parents to ask their blessing every morning, and even grown-up sons were expected to keep their hats off in their parents' presence and daughters to stand up or kneel in the company of their mothers.[18] By the mid-seventeenth century these conventions of deference were beginning to go out of fashion. Cornelius Johnson's

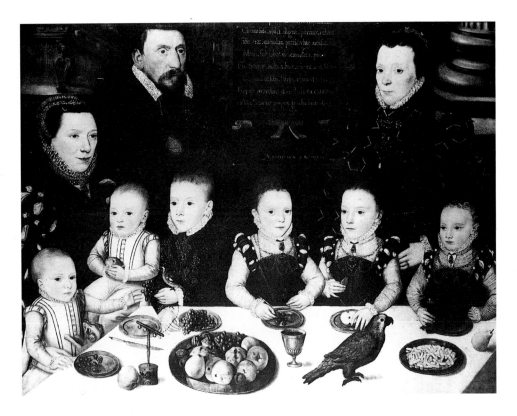

Master of the Countess of Warwick
William Brooke, 10th Lord Cobham and his Family 1567
Reproduced by permission of the Marquess of Bath, Longleat House, Warminster, Wiltshire

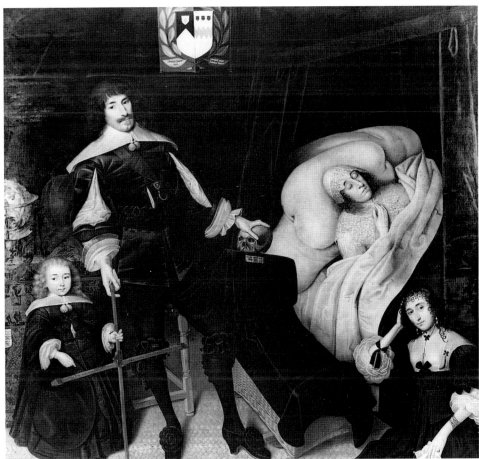

John Souch
Sir Thomas Aston at the Deathbed of his Wife 1635
Manchester City Art Galleries

portrait of the Capel family (cat.10), an expression of the interplay between formality and informality, reflects the change. All the family members are lined up to display themselves to the viewer, with Lord Capel as the focal point. The patriarchal message is made natural and intimate by the artist's use of gesture: our eyes travel across the canvas led by the affectionate touch of hands between parents and children.

With the self-involved family groups of Van Dyck and Rubens portraits become increasingly informal, with the focus less on the parents than on their children, who are shown as mischievous or boisterous rather than dignified. The distance can be measured by comparing the formal symbolic meal of the Cobhams, where exotic fruits and animals are displayed on the table in front of the children and act as an indicator of the family's wealth, to the informal tea-table in the de Broke family's private sitting room around which the children romp. Infant naughtiness is much in evidence in late eighteenth- and early nineteenth-century portraits, and the 'self-willed' child makes its appearance in the popular imagination. In Rowlandson's cartoon, *The Mother's Hope*, a small boy screams 'I will have my own way in every thing' before his admiring mother. To some extent a Rousseau-inspired permissiveness may have permeated real life: in one incident, recorded presumably because of its shock value, the infant Charles James Fox demanded that his father, Lord Holland, allow him to get into a huge bowl of cream set on the table for a formal dinner. The bowl was put on the floor for the child to splash around in.[19]

However, such parental indulgence was counterbalanced by Evangelical moral firmness. Isaac Watts' *Divine Songs in Easy Language for the Use of Children*, first published in 1715, sold eight million copies between 1775 and 1850.[20] Deference to parents was particularly stressed:

Have ye not heard what dreadful plagues
Are threatened by the Lord
To him that breaks his father's law
Or mocks his mother's word?

Like Eworth and Zoffany, Frith in *Many Happy Returns of the Day*, 1856 (cat.11, illus. p.26) places his family round a table for a meal — that most enduring symbol of family togetherness. This is not, of course, a portrait of a real family, although Frith is believed to have used himself, his wife and daughter as models.[21] Rather, it celebrates the ideal of family life of this period, ordered, domestic and bourgeois rather than aristocratic. The picture shows a three-generational family, and it was only a little less unusual during the nineteenth century than at other periods for grandparents to live with their married children.[22] Ironically, Frith found the model for his grandfather in the workhouse.[23] Ruskin was critical of the petted children in this picture and the lack of high moral tone which gave a 'sanctified selfishness' to domesticity.[24]

The image of the father at home is one that reflects the impressions of contemporaries. J.S. Mill wrote in 1869 'The association of men with women in daily life is much closer and more complete than it ever was before. Men's life is much more domestic'.[25] The home became in the Victorian imagination a shelter from the complexities of modern life and a fount of spiritual renewal, as Ruskin's definition in *Sesame and Lilies* makes clear: 'This is the true nature of home — it is the place of Peace, the shelter, not only from all injury, but from all terrors, doubt and division'.[26] The ideal was thought to be located more among the rural lower class than in an upper-class milieu. Dickens makes his aristocratic families almost uniformly unhappy, and the Cranbrook Colony artists who painted sentimental scenes of working-class cottage life were praised by critics in terms which seem today to create a nostalgic and reactionary myth of rural content: 'As long as an interesting mother dotes over her lovely infant — as long as the husband is prosperous in his work and happy in his pipe and ale — as long as the sunburnt children ... go forth in joyous bands to glean the harvest field — as long as sunshine streams in at the cottage window and content smiles from every face — what

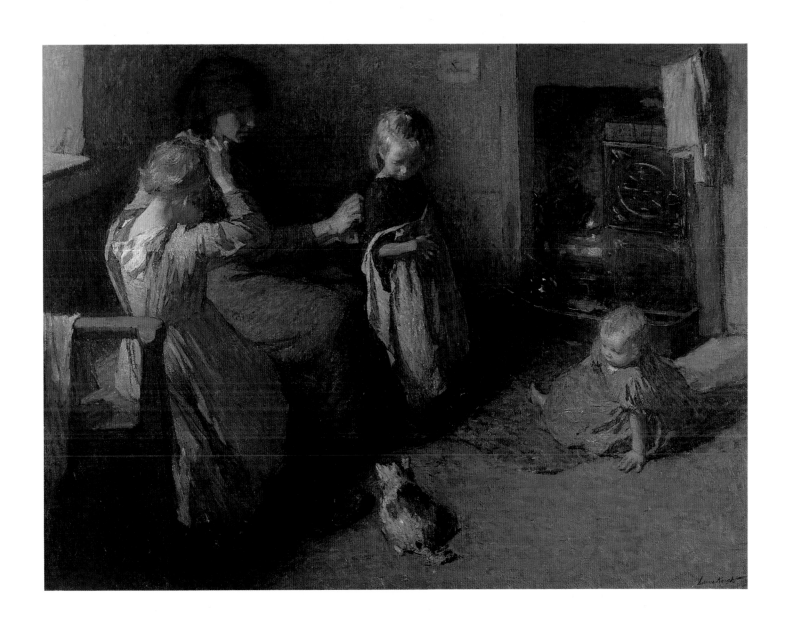

Dame Laura Knight
Dressing the Children c. 1906
Ferens Art Gallery; Hull City Museums
and Art Galleries

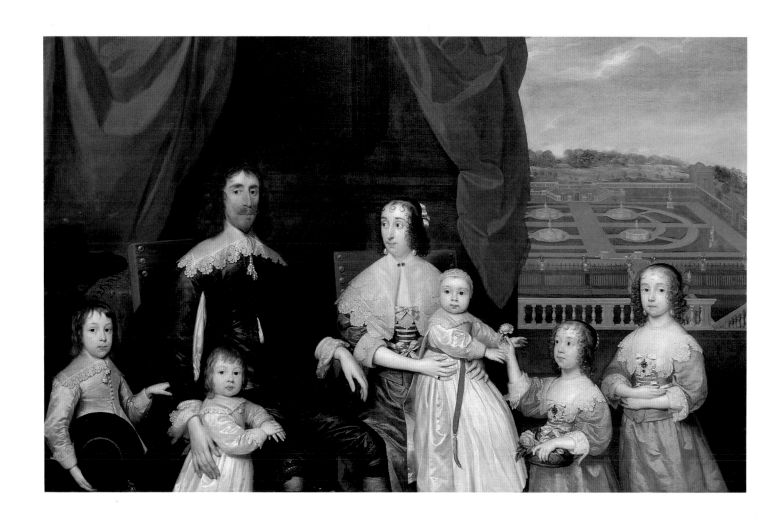

Cornelius Johnson
The Capel Family c. 1640
National Portrait Gallery

cares the painter or the peasant for the politician's suffrage?'[27]

The nineteenth century's interest in the perfect family is underlined by its obsession with its antithesis, the broken family. Paintings which tackle the subjects of foundlings, orphans, adopted children and widowed mothers abound, from Emma Brownlow's series for the Thomas Coram Foundling Hospital, where she herself grew up, to Frank Holl's *The Lord Gave and the Lord Hath Taken Away* (1868, Guildhall Art Gallery) and *No Tidings from the Sea* (1870, H.M. The Queen), which dramatise the economic plight apt to befall families whose breadwinner died. In general, portrayals of urban vagrants, as Susan Casteras has pointed out, show families without fathers, and although

R.B. Martineau
The Last Day in the Old Home 1862
Tate Gallery

destitute mothers and children were statistically common, this theme probably had less to do with historical fact than with a desire to stress the unthreatening and helpless nature of the poor.[28]

If Ruskin saw the family home as a haven he also realised that it could be the opposite: 'If the inconsistently-minded, unknown, unloved or hostile society of the outer world is allowed by either husband or wife to cross the threshold, it ceases to be home; it is then only a part of that outer world which you have roofed over and lighted fire in'.[29] The precariousness of the home's sanctity is depicted in Augustus Egg's series *Past and Present* (1858, Tate Gallery). In the first picture the little girls' collapsing house of cards mirrors the imminent break-up of the home caused by their mother's adultery. In the following paintings their bourgeois drawing room gives way to a cheerless garret and finally to the Adelphi arches. In R. B. Martineau's *The Last Day in the Old Home* (1862, Tate Gallery), the family home is associated with social and financial instability: the father has gambled away his ancestral home and is drawing his son into bad habits while the mother looks on in hopeless anxiety.

When home ceases to be a sanctuary the private world of the family can seem less reassuring than psychologically threatening or damaging. Cynical or ironic views of the family coexist in the nineteenth century with eulogistic ones. Samuel Butler wrote 'I

believe that more unhappiness comes from the source of the family than from any other. The mischief among the lower classes is not great but among the middle classes it is killing a larger number daily'.[30] Thackeray looked back with a jaundiced nineteenth-century eye at eighteenth-century family portraits:

> Some few score years afterwards, when all the parties represented have grown old, what bitter satire there is in those flaunting childish family-portraits, with their farce of sentiment and smiling lies, and innocence so self-conscious and self-satisfied ... The mother lay underground now, long since forgotten – the sisters and brother had a hundred different interests of their own, and familiar still, were utterly estranged from each other.[31]

The decline in the idealisation of the family is a consequence of its progressive loss of privacy and independence. In the last hundred years the history of the family is one of increasing state intervention as compulsory education and the limitation of work for children were gradually enshrined in meliorist legislation. From the 1880s the newly founded NSPCC established that children had rights against mistreatment by their parents and the so-called 'Children's Charters' from 1894 to 1908 laid down that the state would step in when parents neglected their duties. Some saw this as the end both of parental responsibility and of the family itself[32] (a reaction which may be compared, perhaps, to critics of child abuse prosecutions today). Child care theory in the early twentieth century reinforced the increasing lack of trust in the family. The Child Study Movement and the popularisation of Freud's ideas about infant sexuality gave new emphasis to the physical and psychological health of the child. Mothers, particularly working-class ones, were encouraged to abandon traditional ways and go to lessons given by professional bodies (the forerunners of baby clinics) on nutrition, health, education and cleanliness.[33]

L.S. Lowry's paintings and drawings of families express this more problematic view of family life (illus. p.26). Here, the private world is no longer a refuge but one that is psychologically damaging and claustrophobic. His grimly stiff groups of mothers, fathers and children stress their mutual hostility and lack of relationship rather than their closeness. Carel Weight's *The Silence*, 1965 (cat.13), although ostensibly about remembering the dead on Armistice Day – the missing family members who should fill the spaces between the living – is also an image of modern anxiety about isolation both between individuals and, in the wall that separates this household from next door, of that between the family and the rest of the world. Paula Rego dissects the family power structure from the child's point of view. *The Family*, 1988 (cat.15), and other works such as *The Policeman's Daughter* (1987), express the post-Freudian interest in a child's ambivalent view of its parents in which rivalry and aggression are combined with love.

Despite such images of isolation or claustrophobia we are still very responsive to the tradition of the family as safe refuge from the outside world. The photographs that we take of ourselves record only moments of happy family unity, never trauma or separation. In television advertising, happy families (often seen eating round a table, that disappearing form of family togetherness) constitute ideal images of prosperity and harmony.

Stanley Spencer's painting *Hilda and I at Burghclere* (1955, Private Collection) presents us with a scene of domestic bliss (although their marriage was troubled in reality). He shows himself, his wife and children as completely self-absorbed in domestic tasks and play; our bird's eye view of them emphasises their privacy, as if we are spying on their intimacy. The security of the family in opposition to the outside world is also the subject of Shanti Panchal's *First Day*, 1983 (cat.14, illus. p.29), where parents and a sister close protectively around a boy leaving for school for the first time. Adrian Wiszniewski's autobiographical family group, 1987 (cat.16), is made into a symbolic image of harmony and fertility.

William Hoare
***Christopher Anstey with his Daughter,
Mary*** c.1779
National Portrait Gallery

Paula Rego
The Family 1988
Saatchi Collection, London

24 The Family

Winifred Nicholson
Starry-Eyed 1927
Private Collection

W.P. Frith
Many Happy Returns of the Day
1856
Harrogate Museum and Art Gallery
Service

L.S. Lowry
The Family 1936
Private Collection, Canada

Interestingly, none of these happy families shows anything but the traditional grouping of two parents and children. Contemporary work does not reflect the fact that by 1983 one in eight families in Britain were those of single parents and numbers are increasing by about 30,000 a year. On current trends one in five children is likely to experience their parents' divorce before the age of sixteen.[34] The failure to incorporate these facts is a warning that paintings never correspond in a simply way to social realities. Traditional 'family values' are such a powerful pull that new manifestations of the family structure may continue to await visual embodiment.

Adrian Wiszniewski
Robertson Park 1987
Glasgow Art Galleries and Museums

1. Julia Kristeva, 'Woman's Time', *The Kristeva Reader*, ed. Toril Moi, 1986, p. 206.
2. Catherine Elwes, 'A Language of the Personal in Video Art: One Mother's View', *Mothers*, exhibition catalogue, Ikon Gallery, 1990.
3. *British Art in the 20th Century: The Modern Movement*, exhibition catalogue, Royal Academy of Arts, 1987, p.186.
4. Lawrence Stone, *The Family, Sex and Marriage*, 1977, p.431.
5. Christina Hardyment, *Dream Babies: Childcare from Locke to Spock*, 1983, p.16.
6. Hardyment, p.16.
7. *Athenaeum*, May 26, 1900.
8. Stone, p.153.
9. Jonathan Goldberg, 'Fatherly Authority: The Politics of Stuart Family Images', *Rewiting the Renaissance*, ed., M. Ferguson, M. Quilligan, N. Vickers, Chicago, 1986, p.23.
10. Stone, p.452.
11. Simon Schama, *The Embarrassment of Riches: An Interpretation of Dutch Culture in the Golden Age*, 1987, pp.541-3.
12. J.H. Plumb, 'The Victorians Unbuttoned', *Horizon*, Autumn, 1969.
13. *Hard Times: Social Realism in Victorian Art*, Julian Treuherz ed., 1987, p.89.
14. *Hard Times*, p.85.
15. Steve Humphries, Joanna Mack, Robert Perks, *A Century of Childhood*, Channel 4, 1990, p.54.
16. Ralph A. Houlbrooke, *The English Family, 1450-1700*, 1984, p.18.
17. J-L. Flandrin, *Families in Former Times*, Cambridge, 1979, p.8.
18. Stone, p.171.
19. Stone, p.436.
20. Stone, p.252.
21. Christopher Wood, *Victorian Panorama: Paintings of Victorian Life*, 1976, p.61.
22. Michael Anderson, *Approaches to the History of the Western Family, 1500-1914*, 1980, p.23.
23. W.P. Frith, *My Autobiography*, 1890, p.176.
24. Quoted in C. Wood, p.60.
25. Quoted in Walter E. Houghton, *The Victorian Frame of Mind 1830-1870*, New Haven, 1957, p.342.
26. John Ruskin, *Sesame and Lilies*, 1905, p.137.
27. *Blackwood's Magazine*, July 1860, p.70, quoted in *The Cranbrook Colony*, exhibition catalogue, 1981, p.11.
28. *Hard Times*, pp.131-2.
29. *Sesame and Lilies*, p.137.
30. Quoted in C. Wood, p.59.
31. W.M. Thackeray, *Vanity Fair*, 1869, I, ch.xxiv, p.254.
32. Hugh Cunningham, *The Children of the Poor: Representations of Childhood since the 17th Century*, Oxford, 1991, p.206.
33. Hardyment, pp.98ff.
34. Humphries, Mack and Perks, p.58.

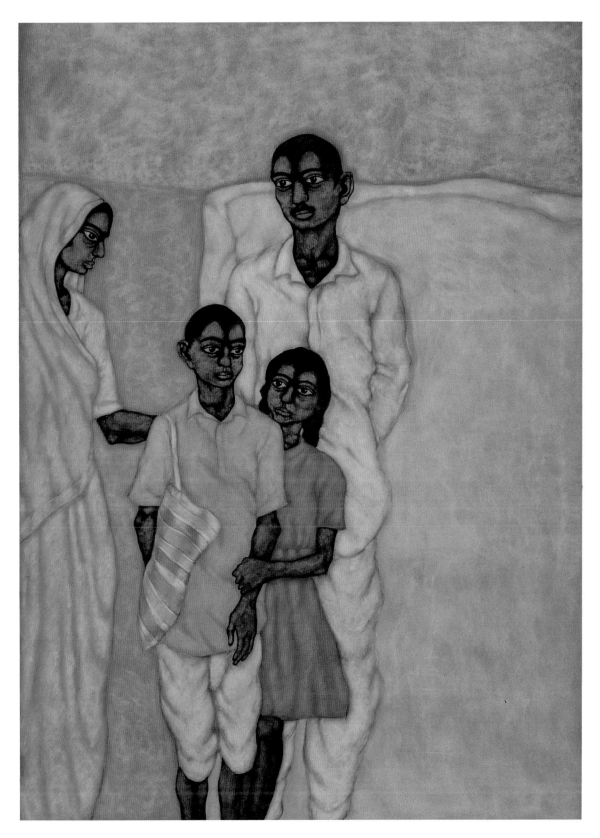

Shanti Panchal
First Day 1983
Bradford Art Galleries and Museums

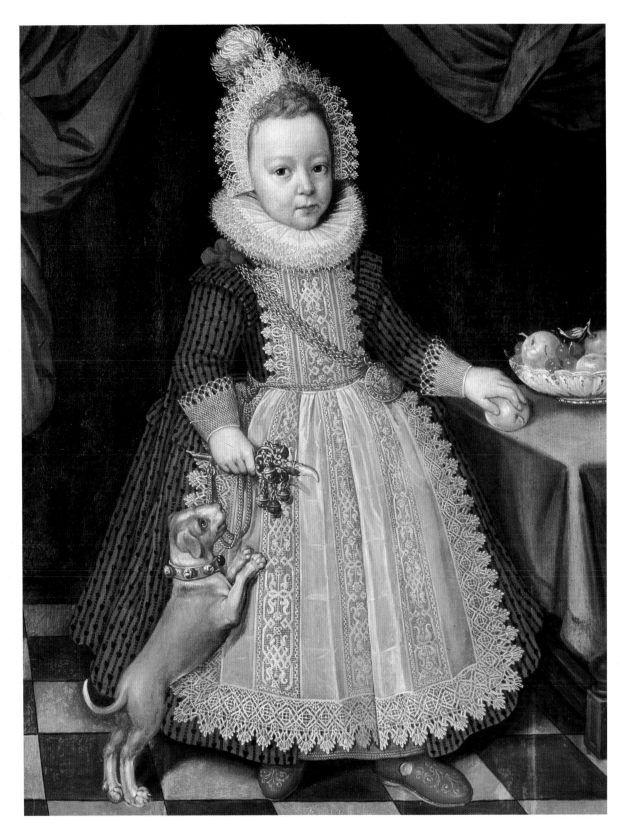

Paul Van Somer (attrib.)
Child with a Rattle 1611
Leeds City Art Galleries (Temple
Newsam House)

A Sense of Identity

Joan Crossley

A number of paintings and drawings in the exhibition focus on the character or individual identity of the child. What are the forces that shape identity, and how have artists attempted to portray the emergent personalities of children? The first essay examined the child against the formative background of family life. The works discussed show how richly various the experience of family can be, that these relationships can be negative or positive, enabling or damaging. This essay examines portraits and other works which attempt to record or probe the character of individual children.

Child Portraiture

All portraits of children have one thing in common; they were commissioned and painted by adults. The image of the child is the result of a collaboration between patron and artist, in which the child is a passive object, and because of this the qualities displayed in the portraits are those selected as important or attractive by a parent or guardian. This is particularly striking in the case of *Child with a Rattle*, 1611 (cat.17), attributed to Paul Van Somer, whose subject is now believed to be the second Earl of Arundel. The fact that the boy is an aristocrat and the future head of one of the most powerful dynasties in the land is easily discernible. Portraitists in this period were less interested in showing the features of the sitter than in describing his or her social position. The child's pose is unusually authoratative and adult. It may be designed to evoke comparisons with military leaders. The child's social status is also defined by the elaborate embroidery of his dress. The medallion, so prominently displayed, has been identified as an Elizabeth I gold sovereign and it is typical of the kind of christening gift given to important babies. It may also be there to remind the viewer of the child's close proximity to the royal family, since the late Queen was related to the Howards through her mother, Anne Boleyn. The portrait would have hung in a public setting, probably with other dynastic portraits, since it is a statement not just about the child but about his position in the world and in his family.

Lely's portrait of *Lady Charlotte Fitzroy*, c.1672 (cat.63), Charles II's illegitimate daughter, was painted at the time of her betrothal. Her parents, Barbara, Duchess of Cleveland and Charles II, doted on the child and were proud of her beauty. Although she was only eight, the picture seeks to show her womanly qualities and her aristocratic breeding; her desirability as a potential wife and future family member. Many portraits were concerned to present children not as they were at the time that the picture was painted, but as they would become. In such portraits childhood is not beautiful or valuable in itself, but for the future adult who can be discerned in the child.

Van Dyck's *Five Children of Charles I*, 1636–7 (cat.18, illus. p.37), was one of the most influential portraits of English children. Its low viewpoint, which brings the viewer face-to-face with the royal offspring, and the richness of the textures and colours set an enduring standard for the glamorous representation of children. The expressions of the three elder children are strikingly serious, with none of the childish joy of Hogarth's *The Graham Children*, (cat.31). Van Dyck depicted them with the melancholy demeanour fashionable at the time. The air of intimacy and informality created by the lively babies on the extreme right and the slight movement of the prince and princess on the left disguise the careful structuring of the painting. The heir to the throne stares out at the viewer with a thoughtful, intelligent gaze. The huge dog is quiet and submissive under the small firm hand. The control of brute nature, symbolised by the dog, gives the prince authority without recourse to such royal status symbols as crowns and batons. It is noteworthy that dogs play an important role in child portraits, whether as cuddly pets to suggest playfulness, or as subservient admirers, to indicate the superior authority of the child sitter.

The names and dates of the birth of the children were inscribed in the top left hand

corner of the original painting, in the collection of Her Majesty The Queen. The commissioning of the portrait tells us a great deal about Charles I and his era. It was one of the first family groups of royal children and indicates the King's desire to be seen as a family man and father as well as the head of a Royal line. He felt himself to be father of the nation, appointed by God to rule as a wise and absolute patriarch. The beautiful, well-ordered and happy family displayed here is a microcosm of the happy family of Great Britain in which Charles I wished to believe. Charles took the visual representation of himself and his family very seriously. He is said to have been displeased with an early portrait of his heir which showed him in baby dress and might have suggested effete babyishness in a future king of Great Britain.[1] Portraits of members of the royal family did not function primarily as private images. They were sent to prominent aristocrats and European courts, advertising the order and love in Charles' family and the security of the Stuart dynasty embodied in the two sons and the marriageable daughters.

Charles I's children are ordered on canvas according to their age, sex and thus importance to the state. The eldest son is given prominence, his brother is next to him, and the girls and babies are relegated to the sides of the canvas. Portraits are often highly revealing about the distinctions and tensions between the children in a family, no doubt because relationships between siblings are an important part of the formation of identity. Studies have shown that position within the family may have an impact on career achievement, self-confidence and independence. In the case of families with wealth and titles, position within the family was vital. Under the English law of primogeniture (inheritance by the oldest male child), the situation of the younger sons was always precarious. Their means of subsistence was in the gift of their father and brothers, and this might be withheld. Portraits of children, prior to the twentieth century, frequently reflect the hierarchical ordering within the family. Even apparently informal works such as Wright of Derby's *The Wood Children*, 1789 (cat.33), put the male heir in the central position, with a younger brother and sister in attendance on him.

The function of child portraits varied widely. In the cases discussed above the images are public, calculated to display the sons and daughters to an admiring world. Others are private images, often of the painter's own children, which explore a newly-formed personality or attempt to fix the fugitive beauty of the child on canvas. Ford Madox Brown painted a beautiful portrait of his son Oliver, *The English Boy* (cat.19, illus. p.38), in 1860, when he was five years old. The child is glowing with health, vitality and intelligence. Oliver was to be something of a prodigy, with talents for painting, drawing and writing. The pride felt by Brown in his son's qualities is evident. Interestingly, the title of the work does not refer to the boy's name but his nationality. Although surely chosen light-heartedly, it does imply that Brown felt his son to be an ideal specimen of English boyhood.

In comparison with *The English Boy*, Bernard Meninsky's *Boy with a Cat*, 1927 (cat.21, illus. p.39), is a more troubled and psychologically complex work, Meninsky's family was broken up by the desertion and death of the mother of his two sons, who were split up and sent to friends at different ends of the country. This portrait was painted on one of Meninsky's visits to his son, David. The boy's body-language suggests anxiety and psychological withdrawal, and the mental distance between father and son as a result of their physical separation.

The contrast between Ford Madox Brown's and Meninsky's portraits of their sons owes much to the development of psychology in the twentieth century. Freud and other psychoanalytical writers emphasised the importance of childhood as the time of the formation of the psyche. The impulses, neuroses and obsessions of the adult were believed to be created by the traumas of the child/adolescent. Obedience, goodness and other Christian virtues came to be regarded as less important to the child's character than happiness and confident self-expression. Twentieth-century portraits focus on the

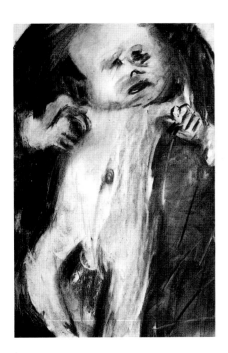

Dennis Creffield
Anxious Baby 1983
Private Collection

character rather than the status of the child-sitter.

Dennis Creffield's baby son in *Anxious Baby*, 1983 (cat.24), is shown as a squalling, gangly newborn first confronting light and sensation. He appears to be frenzied with anxiety: perhaps the artist's own fears about paternity are projected onto the baby. Advice manuals on child-rearing all stress that parents are responsible for the happiness and 'normality' of their offspring. Is the misery or uncertainty of the new-born the fault of the parent or are such characteristics innate?

Joan Eardley lived and worked in the working-class tenements of Glasgow, and was particularly interested in drawing the children who visited her studio. It is clear that Eardley did not want to idealise children; she may even have selected those whose physical imperfections seemed to reflect their deprivation and loneliness. The stillness of the images contrasts with the liveliness and energy of the paint surface, and the personalities of the sitters are sympathetically observed. *Philip the Fat Boy*, *c*.1950 (cat.22), looks desolate and outcast, yet he has been reading comics, symbolic of vitality and non-conformity.

Many portraits of children draw upon historical models or use historical costumes. Van Dyck's glamorous and solemn children recur in eighteenth-century portraits by such artists as Reynolds and Gainsborough, and these painters themselves inspired Victorian painters of children such as Millais.[2] Millais' *Little Speedwell's Darling Blue* (1892, Walker Art Gallery, Liverpool) shows a small girl in eighteenth-century costume, sorting her flowers in a landscape highly reminiscent of Reynold's *The Age of Innocence* (*c*.1788, Plymouth City Museum and Art Gallery). It is interesting to speculate on the reasons for this nostalgic element in post-Romantic images of children. Our own childhood is the site of nostalgia; it is located in the past, and is therefore coloured by our tendency to view the past as a golden, pre-lapsarian age, more innocent and less complicated than the present. The placing of children in historical settings can be seen as an expression of the adult desire to protect them from the complexities of contemporary adulthood, to keep them young and as separate from adult experiences as possible. Moreover, only by keeping children young can they be controlled by their parents. It has been pointed out that children's dress also reflects this desire to cling to the past. The 'best' outfits of contemporary children are the everyday smocked dresses and sailor suits of their Edwardian counterparts. Children are often dressed for weddings in anachronistic fantasy outfits (as, of course, is the bride). These costumes enable adults to indulge in allusions to almost-forgotten Scottish ancestry, or to create the illusion that their child is a little Lord Fauntleroy or a Van Dyck prince.

Gender and Identity

Boy or girl? The first question asked about any new baby is about its sex. Gender is probably the most important influence on our identity within society. The process of learning what our culture considers suitable for our sex starts when we are tiny babies. The centrality of gender in human life is indicated by the fact that almost all the paintings in this exhibition are predicated upon the belief that the two genders have different roles and characteristics. The gulf between the masculine and feminine character was believed to be wide, and children were inculcated with the desirable qualities of their gender. The ideal qualities for a boy were those necessary for survival in a hostile world: aggression, self-assertion and independence. Female virtues were connected to the inescapable destiny of girls to marry and rear children. Religious piety, chastity, patience, self-abnegation were all urged on girls, so that they would make faithful and obedient wives and in turn raise Christian children. For the most part female education and training were based in the home, but boys were sent away to neighbours or to school from about the age of seven. The female sphere was the home (even when girls were sent into service to other homes), whereas men were expected to occupy the

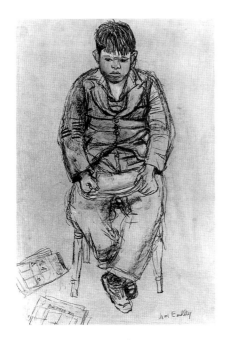

Joan Eardley
Philip the Fat Boy *c*.1950
City of Edinburgh Art Centre

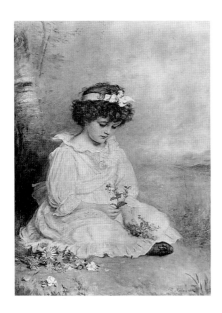

Sir J.E. Millais
Little Speedwell's Darling Blue 1892
Walker Art Gallery, National Museums
and Galleries on Merseyside

public sphere of work, business and politics. This division between the male and female areas of experience is mirrored in sixteenth- and seventeenth-century paintings such as Cornelius Johnson's portrait of *The Capel Family*, c.1640 (cat.10), which allocates the girls to the side of the mother, against a background of an enclosed garden. The boys are aligned with their father against a grand Baroque backdrop, evidently symbolising their future at Court and in the world of public affairs.

In the Romantic period, despite its more liberal attitudes to child-rearing and the emergence of early feminist writers such as Mary Wollstonecraft, belief in fixed and separate roles for men and women was scarcely disrupted, and in the nineteenth century the behaviour expected of the 'lady' and the 'gentlemen' at all stages of life was rigidly codified. Images of the ideal daughter abound in Victorian art; she is shown reading to Papa, comforting Mama, tending younger siblings, putting the interests of her family before her own. The superior moral nature of Woman was proclaimed: she was naturally 'better' than man but also inevitably subservient to him. An article in a contemporary journal on the joys of having a daughter sets out what now appears a chilling programme for the baby's future:

> The mother of the little woman-child sees in her the born queen, and at the same time, the servant of the home; the daughter who is to lift the burden of domestic cares and make them unspeakably lighter by taking her share of them; the sister who is to be a little mother to her brothers and sisters; the future wife and mother in her turn, she is the owner of a destiny which may call on her to endure much and to suffer much, but which, as it also bids her love much … is well worthy of an immortal creature…. A family without a girl lacks a crowning grace, quite as much as a family without a boy misses a tower of strength.[3]

Kate Greenaway's *The Garden Seat* of the 1890s (cat.38, illus. p.40) emphasises the different activities expected of boys and girls. The little boy is armed with a hoop, an active, physical toy, whereas the little girl has no apparent source of amusement except to watch her brother. She is planted firmly on the bench, probably to keep her elegant clothes clean. Girls were believed to be more delicate in health than their brothers, and were discouraged from exposing themselves to draughts or acquiring damp feet. Greenaway's image of a high-walled garden is a symbol of the restrictive but safe life of middle-class women and children. The boy will be able to escape into the freedom of adult male life, but the girl will remain in the protective, restrictive cocoon of home and family.

The imagery of desirable behaviour for young girls is remarkably unchanging in paintings from the seventeenth to the mid-twentieth centuries. Care of small siblings is a recurrent occupation for little girls in portraits. In playing with the baby (Hogarth's *The Graham Children*, 1742 (cat.31), and Johnson's *The Capel Family*, c.1640 (cat.10)) the daughters demonstrate a motherliness which is portrayed as both 'natural' and desirable. Their early assumption of responsibility for the care of others provided an assurance that they would creditably fulfil their role of wife and mother.

A Sense of Identity

Identity in the seventeenth century was determined primarily by status, family and gender. Portraits of children from this period show them mirroring their parents and aspiring to be like them in every way. The children of the *The Capel Family*, c.1640 (cat.10), are grouped around the parent whose role they will emulate, their certainty reflecting the rigid structures of domestic and social life at this time. The personality of children, their individuality, was not the focus of attention, as much as the degree to which they fulfilled the roles that their gender and station laid down for them.

The Romantic movement fostered an interest in adolescence as a time for developing

the imaginative and poetic powers of the young, unfettered by the responsibilities of adult life. Henry Edridge's portrait of *John and Charlotte Vere Poulett* (1801, Cecil Higgins Art Gallery, Bedford) shows a Regency boy and girl in their mid teens. They stand together on a classical terrace overlooking a landscape garden, dreamily absorbed with the music she plays on a guitar. The young man has romantically ruffled hair and leans negligently against the balustrade in defiance of conventional etiquette, allowing his thoughts to roam. Early manhood as a time to allow the imagination and sensibilities to run free may also be seen in Sir Thomas Lawrence's *William Linley* (c.1788, Dulwich Picture Gallery). The young man has the flowing hair and shadowed eyes which conventionally denotes a poetic and imaginative spirit.

In the late eighteenth and nineteenth century childhood was increasingly prolonged in the affluent classes. Daughters were kept 'in the schoolroom' until about the age of seventeen, when they were allowed to put up their hair and enter adult society. The dress and occupations of young men and women were not very different from those of their elders, and adolescence was spent learning how to be a grown-up. The prolonging of childhood much after babyhood remained an economic impossibility among poorer families, where children were expected to start work at an early age. After the Second World War, with the institution of compulsory education up to the age of fifteen (and later sixteen) a new group of leisured, fairly affluent 'teenagers' was created. Teenage fashion in dress and music established rebellion against adult authority as an essential component of adolescence, crucial to the development of individual character.

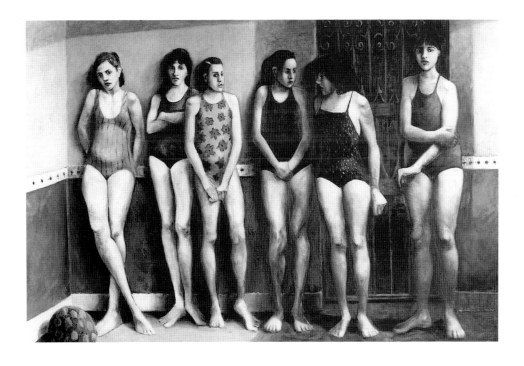

Kathryn Ensall
Girls in Line at the Swimming Baths 1988
Provident Financial, Bradford

Sonia Boyce's *Big Woman's Talk*, 1984 (cat.29, illus. p.41), is the adult artist's attempt to negotiate her feelings about her family and her cultural background. In this self-portrait she goes back, beyond adolescence, to herself as a child. Sitting on the knee of a female relative, she learns about the experiences of an older generation of black women. Boyce has stated her ambiguous feelings about the family as an oppressive but necessary institution. The sense of sifting the values and ideas of the older generation is embodied in the silent, thoughtful little girl.

Kathryn Ensall's *Girls in Line at the Swimming Baths*, 1988 (cat.28), was painted from her recollections of adolescent embarrassment. As they wait to swim or change the

girls are lined up in a parody of a beauty contest. They are uncomfortably aware of being on display, self-conscious about their physical imperfection when compared to stereotypes of feminine beauty (whatever the prevailing ideal might be). The burden of having to be desirable is not something that creates a bond between the girls: few of them are talking, most look lonely and afraid. Their mutual alienation reminds us of children's cruelty to those who do not fit in, who do not look right, sound right or wear the right clothes. In their way these girls on parade before an invisible male are versions of little Charlotte Fitzroy, dressed up at the age of eight to attract a husband.

James Cowie's *Falling Leaves*, 1934 (cat.27, illus. p.42), is concerned with the anxieties of an earlier generation of schoolgirls. Here, their fears are not so much with their sexual but their creative identity. They are drawing in the school art room, which is decorated with a cast of a sculpture by Michaelangelo, the archetypal male genius. The robust sensuous figure stands in poignant contrast to the lack of confidence in the aspiring artists. The falling leaves, seen through the high window, may symbolise the passing of time and missed opportunities. The picture can be read as a warning against the stifling of life by formal education.

If Ensall reminds us of the sexual competition between young girls and adolescent feelings of isolation, Peter Blake celebrates the comradeship of children which comes from shared enthusiasms and preoccupations. Blake was interested in the comparatively new phenomenon of youth culture with its emphemeral fads and crazes. His *Children Reading Comics*, 1954 (cat.26, illus. p.43), is based on a snapshot of himself and his sister as children. They are companionably oblivious of each other, reading the *Eagle*. Captivated by the comics which will influence their play and their vocabulary, they are at the mercy of consumer culture which tempts them with 'free offers' and things to buy. The contrast between their ordinariness and comic book heroism is touching. The boy is bombarded with images of masculinity which he will carry with him into adult life and shape his expectations. The fast pace at which youth crazes replace one another means that parents find it difficult to keep up with new slang, fashions and heroes.

The parent of the growing child may suffer feelings of loss or rejection as the child becomes an independent individual. Eileen Cooper's *Play Dead*, 1991 (cat.30, illus. p.43), is a perceptive exploration of her experience as the mother of a male child. As the boy grows and becomes absorbed by masculine culture, the closeness between mother and child is broken. She feels herself becoming a less important presence in his life, a feeling symbolised by the small scale of her own figure in this painting. Perhaps she feels an instinctive aversion to the violent games which involve 'playing dead'. In this painting the artist/mother also confronts her son's emerging sexual identity. A vigorous lily sprouts from his genitals, suggesting sexual potency but also the perpetual self-regeneration of the family.

1. Oliver Millar, *Van Dyck in England*, National Portrait Gallery, 1982, p.60.
2. Deborah Cherry & Jennifer Harris, 'Eighteenth-Century portraiture and the seventeenth-century past: Gainsborough and Van Dyck', *Art History*, Vol. 5, No. 3, Sept. 1982, pp.287–309.
3. Susan Casteras, *Images of Victorian Womanhood in English Art*, Rutherford, New Jersey, 1987, p.40.

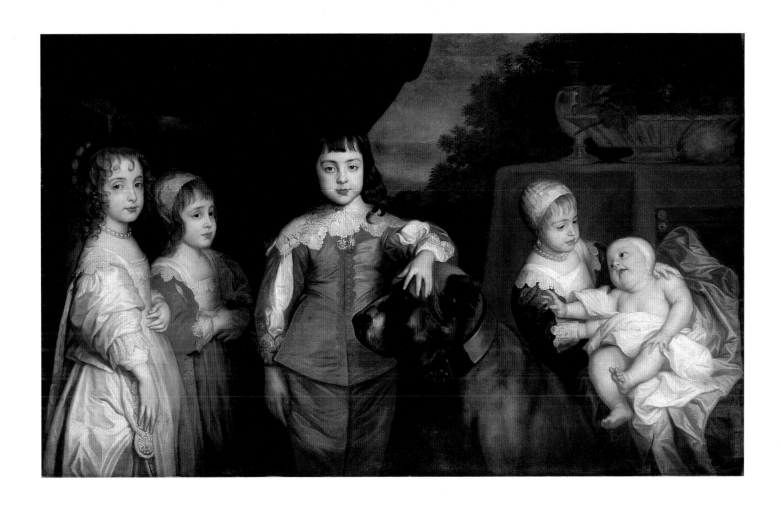

Sir Anthony Van Dyck (after)
Five Children of Charles I 1636-7
National Portrait Gallery

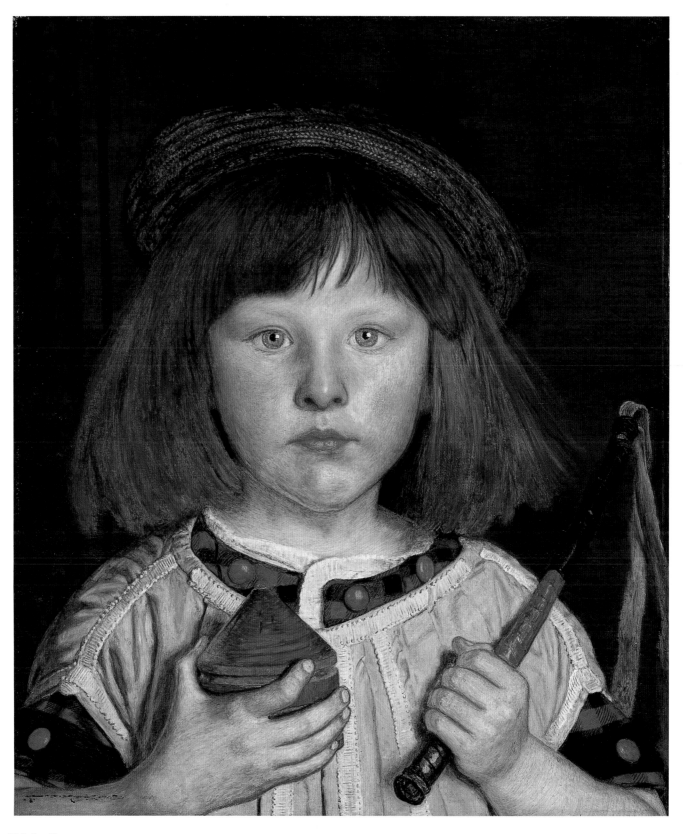

Ford Madox Brown
The English Boy 1860
Manchester City Art Galleries

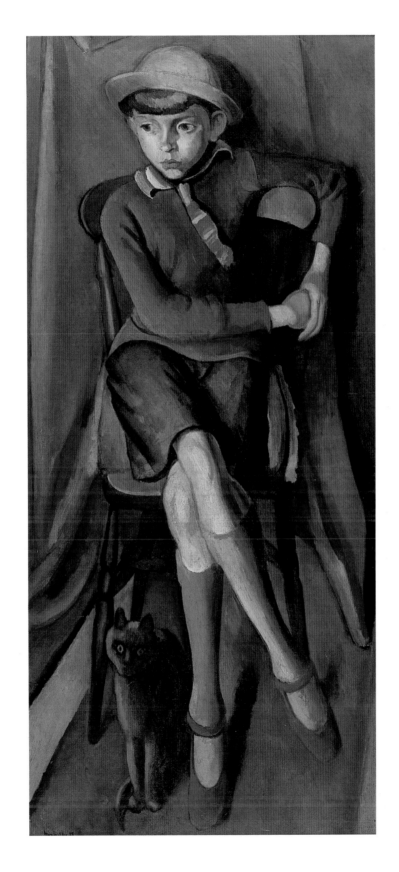

Bernard Meninsky
Boy with a Cat 1927
Hove Museum and Art Gallery

Kate Greenaway
The Garden Seat c.1890s
Royal Albert Memorial Museum, Exeter

Sonia Boyce
Big Woman's Talk 1984
Private Collection

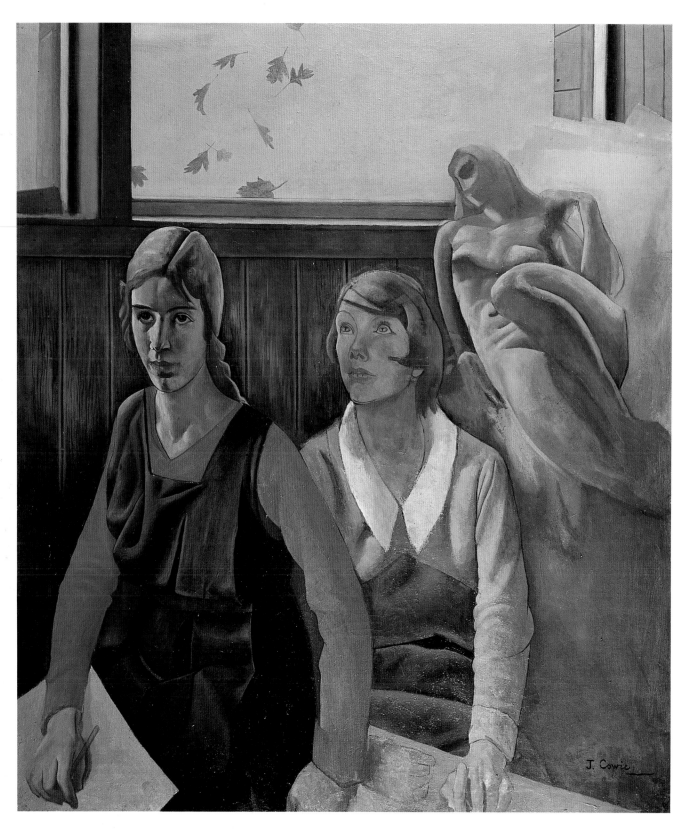

James Cowie
Falling Leaves 1934
City of Aberdeen Art Gallery and
Museums Collection

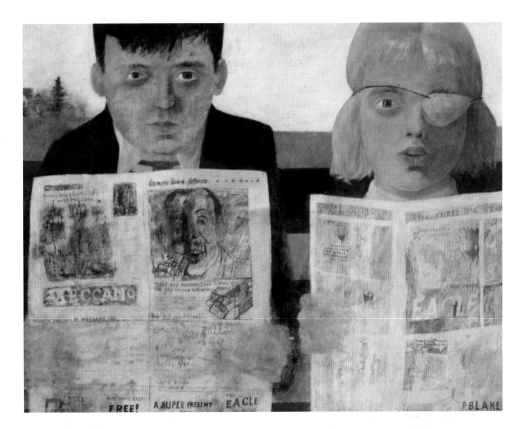

Peter Blake
Children Reading Comics 1954
Tullie House, City Museum and Art
Gallery, Carlisle

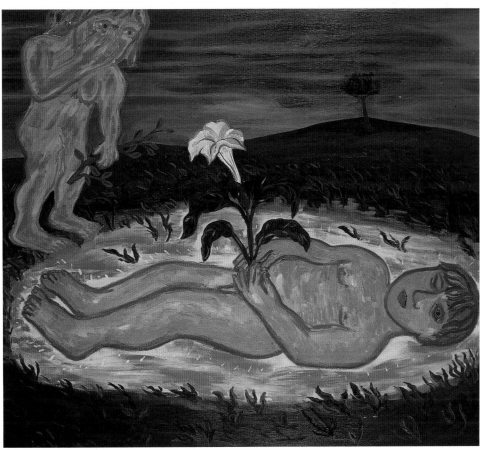

Eileen Cooper
Play Dead 1991
Benjamin Rhodes Gallery, London

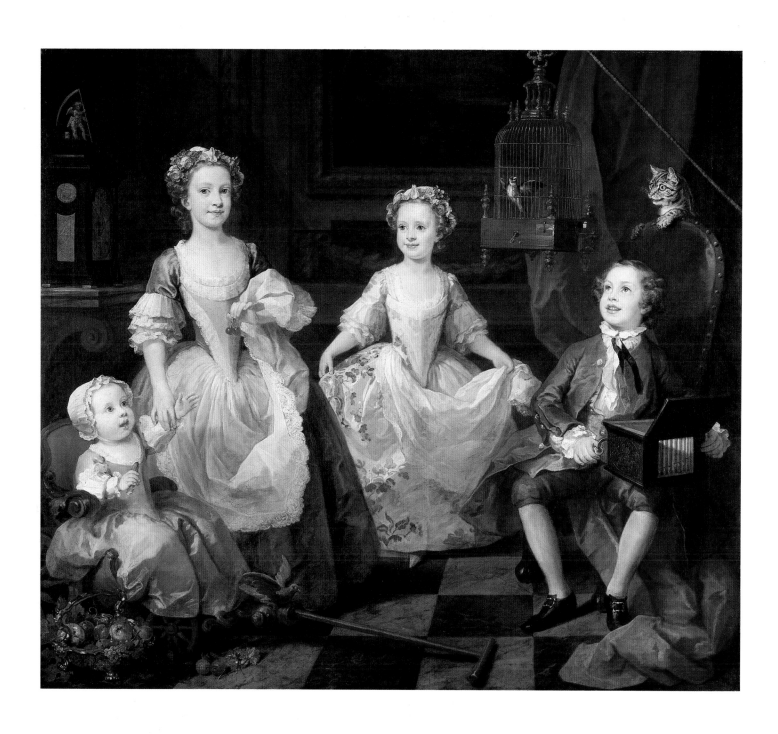

William Hogarth
The Graham Children 1742
Trustees of the National Gallery

44 Work and Play

Work and Play

Sara Holdsworth

Play and the Adult World

'His play is his work' Rousseau said of the child, and for the last three centuries play has been seen increasingly as what marks off carefree childhood from responsible adulthood. Yet, paradoxically, play has always been seen as a preparation for adult life, a way of practising adult roles before they are assumed in earnest. Imitation of adults is the purpose of many favourite games and toys: this was recognised by Maria Edgeworth who in 1789 devised a 'rational toyshop' stocked with miniature carts, gardening tools, presses and looms, as it is by the makers of the toy cars and nurse's outfits of today. It is adults who often desire to prolong childhood; real children, unlike Peter Pan, cannot wait to grow up.

In the typically boisterous manner of eighteenth-century paintings of children, Zoffany's portrait of *The Blunt Children*, 1768–70 (cat.32, illus. p.51), shows two small boys jostling with each other over possession of a rake and a wheelbarrow as they play at being gardeners. This strikes a realistic chord of childhood experience, but their game is also used to make a poignant distinction between the state of being a child and that of being an adult. Zoffany makes the gardening implements much too big for his children to handle and sets them against a vast tree trunk to emphasise their smallness. Many other artists have found the idea of children doing adult things irresistible. Reynolds, for example, in *The Infant Academy*, 1782, shows one fat, almost naked, toddler drawing another who wears only a huge turban and a coquettish expression. The Cranbrook Colony artists, particularly F.D. Hardy and Thomas Webster, specialised in such scenes, depicting children who pretend to be opticians, photographers and soldiers. In Hardy's *Early Sorrow*, 1861 (cat.37, illus. p.51), a group of children imitate a funeral procession, with a dead bird on a toy cart and several mourners. The two adult onlookers show concern rather than amusement at the serious subject of their play. The genre still lives today in advertising images of babies wearing huge spectacles or posed as if they are reading newspapers.

Hogarth's *The Graham Children*, 1742 (cat.31, illus, p.44), is in the tradition of paintings in which children's play is juxtaposed with symbols of mortality and transience. It is as if, by looking at painted children who remain permanently young, we as adults mourn the loss of our own childhood. Everything in this image, as Desmond Shawe Taylor has shown, suggests 'blossoming loveliness and the promise of love'.[1] The picture is full of flowers and fruit, from the basket in the corner and the girls' headdresses to the two cherries held by the elder sister (suggesting by analogy the girls' rosy cheeks and cherry lips). The maternal protectiveness of the eldest sister and the vivacious curtsey of the younger imply their developing femininity. However, innocent playfulness is given a poignancy by the darker images in the painting. A cat menaces a goldfinch, and the impermanence of the children's childhood world is made clear by the inclusion of Time's sickle above the clock. This symbolism gains a further intensity when one is aware that the youngest child had died by the time Hogarth had finished the painting. Moreover, the smiling boy, who is singing to the accompaniment of a bird organ, bears a resemblance to the predatory cat, predicting an adult sexual role as a chaser of female prey.[2]

Play is also used by artists to reinforce roles to which children will be expected to conform as adults. In J.M. Wright's portrait of *Lady Catherine Cecil and James Cecil, 4th Earl of Salisbury* (c.1668, Marquess of Salisbury, Hatfield House, illus. p. 46) the future Earl is raised on a great chair to indicate his rank, and he is surrounded by toys which suggest masculine interests: a horse, a gun and a collection of exotic shells. A dog looks up at him in recognition of his mastery. Lady Catherine is not shown with toys; instead the flowers that she carries make the traditional connection between girls and nature. She hands a pomegranate, a symbol of virginity, to her brother; a gesture which indicates both his future role as guardian of her honour, and, because of the inevitable reminiscence of Eve's giving the apple to Adam, the loss of innocence which will

J.M. Wright
Lady Catherine Cecil and James, 4th
Earl of Salisbury *c.*1668
The Marquess of Salisbury, Hatfield
House

overtake both of them.

In nineteenth-century pictures even greater emphasis is placed on gender specific play. William Maw Egley's *Military Aspirations* (1861, Holburne of Menstrie Museum, Bath), was intended as part of a triptych of the life of a boy who wants to join the army. It shows three neatly dressed, middle-class children playing in the family parlour. The boy, who is the focus of the picture, bangs a drum while one of his playfellows blocks her ears and the other appears oblivious to the noise as she nurses her doll in anticipation of her future role as mother. Victorian images of girlhood often depict an enclosed and restricted world. In Sophie Anderson's *No Walk Today* (1856, Private Collection), a little girl looks wistfully out of a window at the world beyond. The glazing bars suggest her imprisonment, and her stiflingly elaborate costume contrasts with the natural forms of the jasmine and fuchsias of the garden. Kate Greenaway's girls are similarly docile and are almost always shown within a walled garden.

In the last half of the twentieth century artists have begun to question the stereotypes

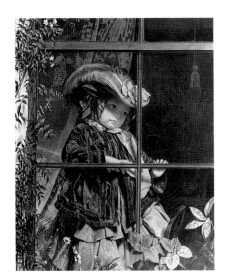

Sophie Anderson
No Walk Today 1856
Private Collection

Bill Woodrow
Tricycle and Tank 1981
Collection of the Artist

of gender-specific play. The little boy's dream of being a soldier has been undercut as war has come to be seen as destructive rather than glorious. George Fullard's 1950s drawing *Children Playing Soldiers* (cat.40) emphasises that their play is a 'bang, bang, you're dead' fantasy of war, while Bill Woodrow's *Tricycle and Tank*, 1981 (cat.60), puts into symbiotic relationship the battered and innocently nostalgic tricycle with a tiny tank, part harmless toy, part symbol of destruction. The relationship between male macho fantasies and sweet girlish docility is exposed by the American artist Barbara Kruger. In her recent photopiece, the words 'we don't need another hero' are juxtaposed with an image, reminiscent of 1950's advertising, of a little girl admiringly touching a little boy's flexed biceps.

Cruelty and Fear

Rowlandson's cartoon of children tormenting a cat and a dog while their father fondly remarks 'Dear little innocents, how prettily they amuse themselves',[3] pokes fun at eighteenth-century notions of Rousseauesque parental tolerance but it also points up the innate cruelty of children which contradicts romantic views of childish innocence. Paradoxically, such dystopian depictions of a child's capacity for barbarity seemed to have gained ground as the belief in Original Sin waned. In Plate 1 of Hogarth's *The Four Stages of Cruelty*, 1751 (cat.39), Tom Nero and the other street boys are shown at play torturing animals. Among other activities they hang a pair of cats, arrange a cock fight and thrust an arrow into a dog's anus. However, Hogarth may mean us to read such behaviour as springing from nurture rather than nature, since he saw the mercantile character of the city as a brutalising and corrupting force.

Whereas Hogarth uses the boys' cruelty to animals as a prefiguration of adult cruelty, other artists have concentrated on such behaviour as part of the essential experience of childhood. Joseph Wright of Derby's *Two Boys fighting over a Bladder* (c.1767–70, Private Collection), in which one child is grimacing in pain as the other twists his ear, is a ferocious example. The bladder, a traditional symbol, like the bubble, of the transience of childhood, suggests, perhaps, the temporary nature of this brutish behaviour. Another work by Wright of the same date focuses on female impishness. In *Two Girls dressing a Kitten by Candlelight* (c.1768–70, Private Collection on loan to the Iveagh Bequest, illus. p.48), the little girls' expressions and gestures are ambiguous: maternal care for the animal shades into a delight in tormenting it. Such pictures make an implicit analogy between children and animals in such a way as to point up the child's own bestial nature and its need for taming. Paula Rego's series of paintings depicting girls with dogs is a contemporary example (illus. p.48). The girls manipulate the dogs, dress and feed them in an atmosphere which is both playful and sinister. It may be that the artist intends the works as allegories of the battle between the ego and super ego and the dark forces of the id.

Freud saw the pre-phallic stage of childhood as remorselessly pleasure-seeking, anarchic, sadistic and aggressive. These qualities are strongly brought out in Mark Symons' *The Day after Christmas*, 1931 (cat.36). Two children and a baby sit amongst the chaotic debris of Christmas toys. The expression of the girl facing us is sullenly unfestive and she raises a stick as if to threaten an unseen adult; her sister lies in wild abandon on the floor blowing a horn and waving a windmill. By contrast, the two older girls, who are carefully piling up their building bricks, are models of restraint and decorum.

The child's potential for cruelty and violence is matched by its sense of fear. This extreme emotional world is dramatised in a comic way in John Faed's *Boyhood*, 1849 (cat.42, illus. p.52), where the aggressive pugilistic schoolboy with his fists raised is contrasted with the wailing misery of his fellow. Among contemporary studies of the secret world of childish terrors, Carel Weight's *Frightened Children*, 1983 (cat.61),

Paula Rego
Two Girls and a Dog 1987
Private Collection

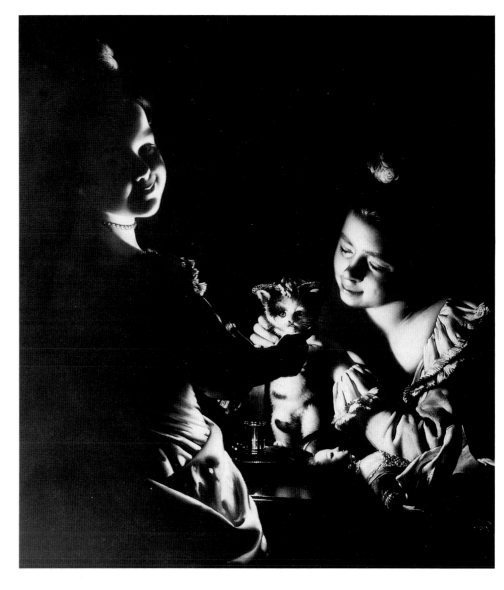

Joseph Wright of Derby
*Two Girls Dressing a Kitten by
Candlelight* *c.*1768-70
Private Collection

shows two children running from something or someone unseen; it is unclear whether it is an enjoyably scary game or a scene of genuine terror. Chris Stevens' *Giant*, 1988 (cat.43), is also an investigation of the nature of childhood fear. The giant bogeyman made by the coat is created by the boys themselves as they stand on one another's shoulders: it is their own imagination which has brought forth the monster.

Play and Nature

From the early seventeenth century artists have depicted children in relation to the natural world. Cornelius Johnson shows the girls of the Capel Family carrying flowers and places them in front of an exquisitely manicured formal garden which suggests that their natures are equally susceptible to training. In other portraits, like Van Somer's *Child with a Rattle*, 1611 (cat.17) or Van Dyck's *Five Children of Charles I*, 1636−7 (cat.18), the dog playmate symbolises the animal nature of the child and its need for careful discipline. Allowing a baby to crawl was for many centuries disapproved of by writers on childcare because it was seen as a reminder of our link with the animal world, and hence of our baser nature.

Christopher Stevens
Giant 1988
Collection of the Artist

By the mid-eighteenth century images of tamed nature were beginning to give way to those of wildness. Rousseau believed that wisdom and morality could be absorbed through contact with nature. A child should be brought up in the way that a tree is cultivated, with careful attention but without unnatural forcing or pruning. Nurses were encouraged to carry their charges outside to 'green fields and sunny eminences',[4] and for older children energetic out-of-doors exercise was recommended rather than book learning. Joseph Wright of Derby's *The Wood Children*, 1789 (cat.33, illus. p.55), reflects the influence of such theories. The children are depicted with bats and a ball in a wild landscape setting and their loose dress and natural hairstyles increase the sense of unfettered spontaneity. One may take this as an illustration of Rousseau's dictum 'Nature wants children to be children'. However, the emphasis on their childish energy is challenged by the hierarchy established in the pose. The eldest son is in an authoritatively central position, and his direct gaze suggests that he is about to renounce play for more adult and dignified concerns.

One of the few books for children of which Rousseau did approve was *Robinson Crusoe*,[5] which he saw as in tune with his ideas about learning from practical experience. To prevent a boy from becoming an insolent aristocratic drone he should cultivate a patch of garden and enjoy the fruits of his labours.[6] How much this egalitarian suggestion actually affected upper class behaviour is not known, but Zoffany's *The Blunt Children*, 1768–70 (cat.32), is an example of a whole genre of paintings which show children with gardening implements. In this painting, in which adult tools stress the children's diminutive stature, not much gardening is being done. The tools do, however, indicate the children's connection to nature.

A pastoral setting became, by the end of the eighteenth century, one of the main touchstones for carefree childhood. For Blake and Wordsworth a child's instinctive joy in nature provided a spiritually regenerating force for the whole of its subsequent experience. The city, on the other hand, became a place of restriction and stunted growth. Blake's mainly pastoral themes in the *Songs of Innocence* give way to urban settings in those of *Experience*. This city/country antithesis is a constant feature of ideas about nineteenth-century childhood. Commentators begin to see the city as anti-childhood, and vagrant 'street arabs' or working children are viewed as a different race from their middle-class counterparts. When Mayhew interviewed a girl who sold watercress he noted 'although only eight years of age [she] had entirely lost her childish ways, and was indeed, in thoughts and manner a woman'.[7] Cartoons of street children, such as those by John Leech, often play comically on their subjects' inappropriately grown-up manner, while other images of working class infants at play emphasise their anti-authoritarian cheekiness or the quaintness of their games.

Ruskin particularly admired those artists like Helen Allingham and Kate Greenaway whom he saw as protesting against the misery of poor children in the city 'by painting the real inheritance of childhood in the meadows and fresh air'.[8] In their work the enclosed and protected world of a garden is presented as the ideal environment for a child, a notion which echoes William Morris's dictum that 'every child should be able to play in a garden close to the place where his parents live'.[9] Like Thomas Hood's 'Past and Present' or R.L. Stevenson's *A Child's Garden of Verses*, Kate Greenaway presents the child in the garden as a consciously nostalgic image. The little boy and girl in *The Garden Seat*, *c*.1890s (cat.38), are dressed not in contemporary clothes but in a version of Regency costume which soon, under her influence, became fashionable dress. The docility of the children heightens our sense that they are imprisoned as well as protected by the great wall which shuts out the modern world.

The importance given in the nineteenth century to a safe world away from the street lies behind the painting of *The Lowther Arcade*, *c*.1870 (cat.35, illus. p. 87). Shopping arcades were designed as exclusive environments which would keep out lower class riff-raff. The Lowther Arcade, off the Strand, was famed for its toyshops, and the painting celebrates a child-centered world. Children's books and toys had been widely available

for a hundred years, and by this date had become a huge industry to meet demands from the increasingly affluent middle class.

By the late nineteenth century the city began to be thought of as unsuitable for the raising of children. The infant mortality rates were the highest ever recorded; in the poorest parts of Liverpool around half of all babies died before the age of one. Between 1868 and 1925 80,000 deprived urban children were sent to Canada as labourers or servants, in what was euphemistically described by one of the organisers as 'spring transplanting'.[10] In London, the educational reformer Margaret McMillan set up a garden school where the children slept out of doors,[11] and seaside and country holidays for poor city children began to be organised by charitable foundations and clubs.

If poor children were to be transformed by contact with nature, then the ideal for their middle-class counterparts was for them to be integrated completely with an idyllic natural world. J.Q. Pringle's *Children at Play*, 1905 (cat.34, illus. p. 56), depicts two

P.W. Steer,
Children Paddling, Walberswick
c. 1889-94
Reproduced by permission of the
Syndics of the Fitzwilliam Museum,
Cambridge

decorously wistful girls wearing the 'artistic' hats and smocks fashionable at the time. Their rather prim look is curiously at odds with their bare feet and legs which echo the pale thin forms of the tree trunks and suggest that they are children of nature as well as the highly decorative products of culture. Philip Wilson Steer's impressionist paintings of children on the beach are joyful evocations of childhood as a period of carefree holiday. Full of light and movement, the figures and landscape are conceived as one. The artist Walter Sickert thought these paintings made you 'feel that sunshine and wind and youth are glorious things'. He also praised Steer's 'natural and spontaneous' grouping of the children and the way that they seem to be 'playing amongst themselves without a trace of self-consciousness'.[12] The subject of children on the beach was taken up by many artists in the early years of this century, most notably Dame Laura Knight and Dorothea Sharp, who continued the tradition of exuberant play in a brightly sunlit landscape.

The cult of the outdoors of the inter-war years was promoted by enlightened municipal authorities who wanted to popularise healthy and safe alternatives to playing in the street. Parks, playgrounds, swimming pools and playing fields proliferated. Since the war, however, our attitude to street games has changed; we tend to look back at this

Johann Zoffany
The Blunt Children 1768-70
Reproduced by permission of
Birmingham Museums and Art Gallery

F.D. Hardy
Early Sorrow 1861
Towneley Hall Art Gallery and Museums,
Burnley Borough Council

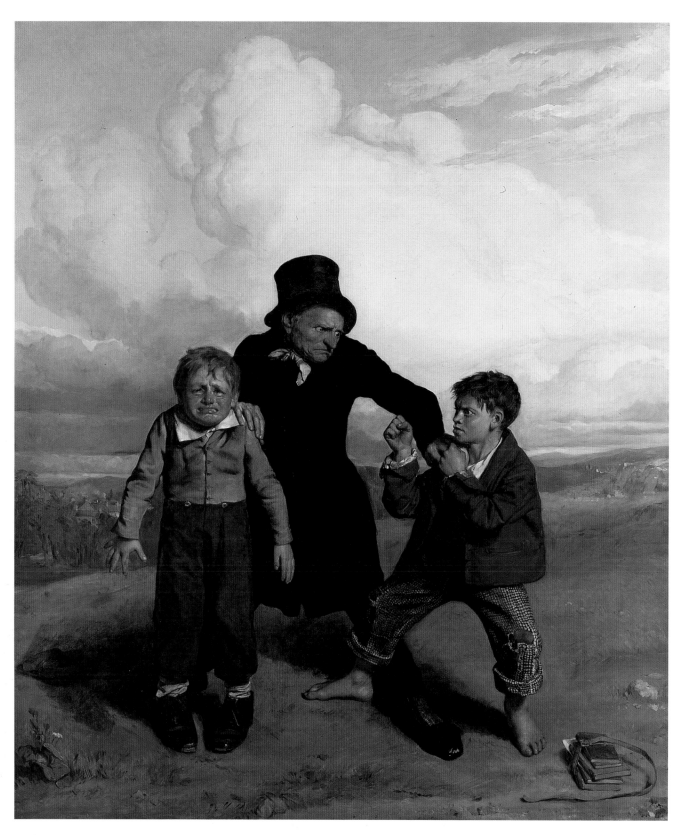

John Faed
Boyhood 1849
FORBES Magazine Collection, New York

aspect of child culture with nostalgia rather than alarm. George Fullard's acutely observed sketches of children have an urban grittiness; he was interested in capturing the way that a child's imagination could transform the humdrum experience of their lives. Joan Eardley's paintings also celebrate city children's vitality. The richly painted patchwork of colours that make up their clothes and their graffiti-covered slum environment express the artist's excitement at life lived on the street.

Peter Blake's paintings of the 1950s, like Eardley's, used graffiti, litter and ephemera to suggest the random variousness of the urban scene. Many of his pictures offer almost anthropological data, based on memories of his own childhood, on the child's seduction by crazes and fads. Blake celebrates the mid-twentieth-century child's consumerist longings as an innocent paradise filled with brand names, pop and film stars and comic book heroes. A stance which is less easy to swallow unironically since the advent of toy megastores and hard-sell television campaigns which aim to make products from sweets to computer games irresistible to children. Street culture has been explored in the last few years by Jock McFadyen and Anthony Davies whose images, which are not nostalgic or autobiographical, capture the ennui and toughness of urban teenagers.

Work

George Fullard
Children and Pushchair 1956
Private Collection

Until this century work has always been part of the lives of poor children. For them, education, if it took place at all, ceased at a very early age; in the seventeenth century as young as eight. Parents were often forced through economic necessity to withdraw their children from school as soon as they could make a contribution to the household. Children's work could be in domestic service, labouring on the land or, from the eighteenth century, in mines, factories and sweatshops, but as often it was at home helping parents with domestic or farm tasks or looking after younger siblings while their parents worked. The care of brothers and sisters remained an important part of some children's experience in the twentieth century. George Fullard's 1956 drawing of a boy wheeling his little sister in a pushchair (cat.41) explores the unsentimental affection between them.

Seventeenth- and eighteenth-century paintings of working children are rare: such mundane subject matters tended to be regarded as more suitable for prints. As with Hogarth's apprentice, Goodchild, images of children and youths are often used to make a moral point about idleness *versus* industry. Gainsborough's depictions of poor children, his so-called 'fancy' paintings, have been read in these terms. John Barrell has suggested that when contemporary viewers, to whom working-class idleness was the greatest social evil, looked at *A Peasant Girl Gathering Faggots*, 1782 (cat.49, illus. p.57), they felt sympathy for her precisely because she is shown at work; her bundle of sticks is intended to be a 'passport to our hearts'.[13] The girl would also have engaged contemporary emotions through her expression of exquisite sensibility. Our gaze is drawn to her face, which stands out in clear detail from the rest of the loosely painted canvas. Her liquid eyes seem to be sparkling with tears and are turned away from the viewer to emphasise her humility. Such 'pathetic simplicity', as it was described at the time,[14] has the effect of making her seem spiritually uplifted by her work rather than brutalised.

Interestingly, artists could also blur the distinction between real work and play. Reynolds painted several pictures of aristocratic children feeding chickens or pushing a wheelbarrow where the activity symbolises their nearness to nature, but their dress and pose mark them out as never needing to work in reality. Zoffany's *The Blunt Children*, 1768–70 (cat.32), belongs to this genre.

From the late eighteenth century child labour began to be seen as an offence to humanity; analogies were made between child chimney sweeps and textile workers and slaves.[15] In 1833 the Factory Act limited children under thirteen to eight hours work a

James Lobley
Ragged School Studies 1859-1880
Bradford Art Galleries and Museums

T.B. Kennington
The Pinch of Poverty 1891
From the Thomas Coram Foundation,
London

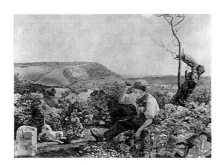

John Brett
The Stonebreaker 1857-8
Walker Art Gallery, National Museums
and Galleries on Merseyside

day; small as this improvement seems, it was the first time that childhood was legally defined in terms of age. The flood of images of working and street children in the mid-nineteenth century was a response to the heightened anxiety about how working-class childhood should be spent. Dr Barnado's famous 'before' and 'after' photographs were made to be sold as *cartes de visite* to raise funds for rehabilitating destitute or vagrant children. From the 1840s Ragged Schools were set up for such children, like the one in Bradford, where James Lobley made a series of watercolour studies of small boys (cat.48), possibly for the Treasurer of the school. Like the Barnado's photographs, Lobley focuses on the children's bare feet, ill-fitting shoes and rags rather than treating them as individuals; some are posed with their heads turned away or with a hand covering their faces.

Images of children working down mines or in factories, the horrors of which were exposed and publicised by the 1842 Children's Employment Commission, are rare outside engravings used to illustrate magazine features. Such children are absent from paintings. Instead, artists concentrated on the type of work which would be most visible and familiar to their urban middle-class audience: images abound of chimney sweeps, flower sellers, crossing sweepers and boot blacks. Young domestic servants, of which there were vast numbers, are rarely pictured, probably because since they were employed by the middle classes they could hardly be objects of their philanthropy.

Ruskin stressed the sweetness of some street children's faces and criticised Murillo's pictures of 'vicious', 'repulsive and wicked' urchins because they did not move the viewer to charity.[16] A much more ironic view had been taken by Disraeli, who in *Sybil* (1845) launched a bitter attack on conditions in industrial England. He suggested that Reynolds' *Angels' Heads*, 1787 (cat.55), which shows the 'celestial visage' of Frances Isabella Gordon, should inspire a contemporary artist to find a similar subject working in a coal mine.[17] Paintings of working children generally echo Ruskin's attitude. T.B. Kennington's *The Pinch of Poverty* (1891, Guildhall Art Gallery) is typical in its appeal to the sentiment of the viewer. The little flower girl looks directly at us, not to make us uncomfortable, but with a beseeching expression to elicit our charity. She has gone down in the world, but – like Oliver Twist who is the archetypal victimised child of Victorian literature – she retains her polite middle-class manners and bearing. John Brett's *The Stonebreaker* (1857–8, Walker Art Gallery, Liverpool) also chooses not to depict the harsher effects of labour on children. The little boy napping flints is set in an idyllic summer landscape and is angelically blond and rosy cheeked. Contemporary photographs of labouring children often tell a different story – one of dirt, rags, malnourishment and deformity.

George Clausen's pictures of country labourers of the 1880s, influenced by the French artist, Bastien-Lepage, were seen at the time as lacking in sentiment and competing with nature in their studied impartiality. This apparently more realistic approach can be seen in *The Stone Pickers* of 1887 (cat.50, illus. p.58), in which the bleak landscape, high horizon and low viewpoint all compel us into a direct confrontation with the girl. Clausen dwells on the largeness of her hands and the heaviness of her boots to indicate that her life is one of manual labour. Although her sorrowful downcast face has a modesty and humility reminiscent of Gainsborough's *Peasant Girl*, the bent old woman in the background adds a grimly prophetic element; she is an image of what the young girl will become after a lifetime's work.

Training and School

Adults have always been concerned with the best way to teach children how to become the mature, well-adjusted people they see themselves as being. Ideas about what kind of moral and social lessons should be learnt, however, and how they should be enforced, have differed widely. Late eighteenth-century Evangelicals like Hannah More, taking up

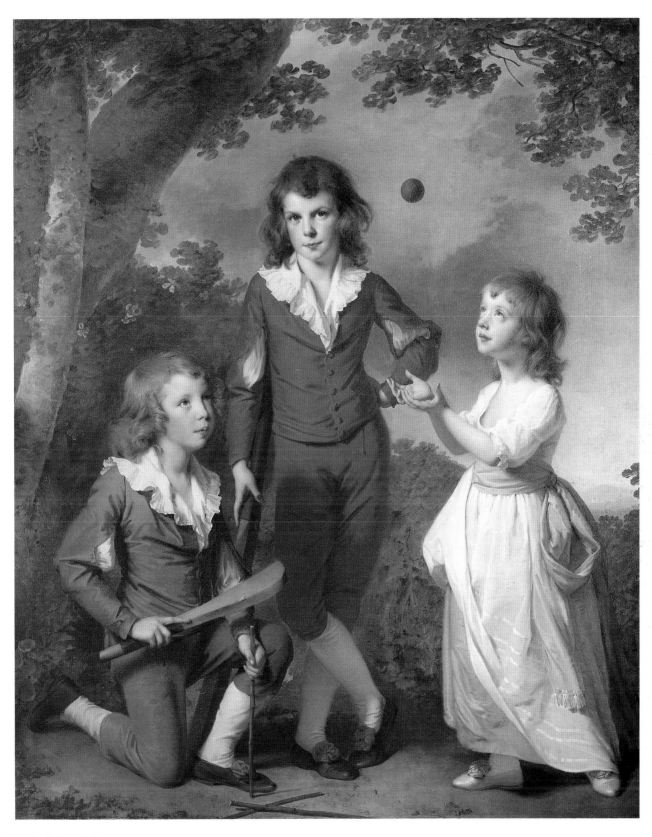

Joseph Wright (of Derby)
The Wood Children 1789
Derby Museum and Art Gallery

J.Q. Pringle
Children at Play 1905
Hunterian Art Gallery, University of
Glasgow

Thomas Gainsborough
A Peasant Girl Gathering Faggots
1782
Manchester City Art Galleries

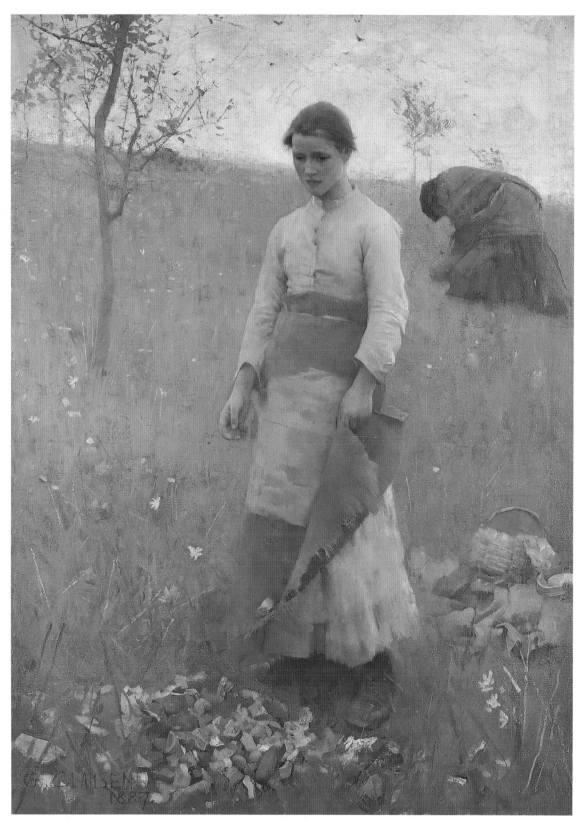

George Clausen
The Stone Pickers 1887
Laing Art Gallery, Tyne and Wear

Blue Coat Schoolboy
late 18th – early 19th century
Maidstone Museum and Art Gallery

the baton of seventeenth-century Calvinist repression, stressed the need for strong discipline. It was 'a fundamental error to consider children as innocent beings, whose little weaknesses may perhaps want some correction, rather than as beings who bring into the world a corrupt nature and evil dispositions, which it should be the great end of education to rectify'.[18] At the other extreme of Rousseau-influenced child-centered views the primary concern of all education was to bring out the identity and nature of the child itself. Others, following Locke, thought that the child's mind was a *tabula rasa*, neither evil nor good, onto which adults had a responsibility to impress rational self-control and the right character. The metaphor used was that of the parent as gardener; children are 'trained' like trees, and faults are 'weeded' out in order to 'plant' good habits.[19]

Mulready's paintings on the subject of child-rearing stress the importance of parental guidance. *The Lesson*, 1859 (cat.1), was exhibited with the quotation 'Just as the twig is bent, the Tree's inclined'. The mother here is imparting a pious lesson 'naturally'. *Train up a Child in the Way He Should Go and when He Is Old He Will not Depart from It*, 1841 (cat.45, illus. p.61), draws on the tradition of rustic charity paintings in which well-off women and children aid the deserving and grateful poor. Mulready's picture has more complex symbolic meanings. It shows a fearful but brave little boy being encouraged to give money to a group of frightening beggars. The brightness of the women and child contrast with the darkness of the beggars, and the setting reinforces the idea of taking the correct path through life, in which benevolence to those less fortunate than yourself constitutes an important lesson on the way.

A less idealistic view of children's morality is taken by Thomas Webster's *The Boy with Many Friends*, 1841 (cat.44, illus. p.61), in which a simple looking schoolboy who has just received a hamper is surrounded by new 'friends' who wheedle him into parting with his goodies and fight with each other for them. Fawning greed, slyness and aggression are treated in a comic way to lighten the message, but the two boys in the background, shocked at what they see, direct our reaction and give the piece didactic weight.

Webster's picture shows a schoolroom without a schoolmaster, and hence the anarchy into which children fall without proper moral and social control. School has always been associated with discipline and authority as much as with the gaining of knowledge. From the sixteenth century the birch is used in prints as an emblem of the schoolmaster, and corporal punishment has always been a more marked feature of schools and other institutions for children than it has been of the home.[20] The charity and industrial schools of the eighteenth century, which concentrated as much on training for work as on education for its own sake, were set up to counter the perceived problem of idleness among working-class children: 'For Satan finds some mischief still/ For idle hands to do' wrote Isaac Watts in 1715. This function of the school as a social strategy for instilling order among the poor is a recurrent theme at this time. A famous poetic example is William Blake's 'Holy Thursday', which concerns the annual occasion at St Paul's Cathedral when thousands of charity children gathered from all over London dressed neatly in their uniforms, to sing Psalm 100 ('Make a joyful noise unto the Lord') before a crowd of philanthropic spectators. Blake depicts the 'innocent' children 'walking two and two' in regimented bands, and the last line of the poem undercuts the complacent benevolence of the occasion by asking us to 'cherish pity; lest you drive an angel from your door'.

The late eighteenth-century wooden figures of the *Blue Coat Schoolboy* and *Schoolgirl* (cat.46, 47) are images of the kind of charity children that Blake wrote about. They originally stood in a church, almost certainly above a collecting box, to which they point. Their neat uniforms advertise the fact that they are recipients of charity and the boy's doffed cap and the girl's book (probably a bible) bespeak virtues of humility, studiousness and piety.

Blake compared the schoolboy to a caged bird, and for many centuries school has

often been presented less as a socialising or civilising institution than a repressive one, to which rebelliousness is a more useful response than obedience. A whole genre of nineteenth-century humorous images (continued in twentieth-century comics) declares the child's naturally anti-authoritarian bias: teachers are either ferocious but out-witted, or feeble-minded and ignored. Authoritarianism is still a potent issue. Ideas about child-centered learning and education through experience may have influenced teaching, but uniforms (not widespread until the 1930s) and strict age segregation are still firmly in place. The school photograph with its rank upon rank of neatly dressed children still lives as the official image of the order and unity of the institution. Pictures about school tend to react against this disciplinarian view of pre-adult conduct. James Cowie's 1934 study of pupils in a classroom (cat.27) and Kathryn Ensall's contemporary teenagers at a school swimming pool (cat.28), although fifty years apart, indicate by their similar placing of figures against high walls the restrictive nature of the institution and the girls' psychological separation from it. Tam Joseph's *U.K. School Report* (Sheffield City Art Gallery), painted in the 1980s, is a mordant comment on the progress of a black child through a white institution, transformed from the model boy praised as 'good at sports' to the dreadlocked teenager who 'needs surveillance'.

Good at Sports likes music Needs surveillance

Tam Joseph
U.K. School Report
Sheffield City Art Galleries

1. Desmond Shawe Taylor, *The Georgians: Eighteenth Century Portraiture and Society*, 1990, p.209.
2. Shawe Taylor, p.211.
3. Lawrence Stone, *The Family, Sex and Marriage*, 1977, p.439.
4. Christina Hardyment, *Dream Babies*, 1983, p.24.
5. Desmond Shawe Taylor, p.191.
6. Desmond Shawe Taylor, p.195.
7. Hugh Cunningham, *The Children of the Poor*, 1991, p.108.
8. John Ruskin, *The Art of England*, 1887, p.143.
9. Cunningham, p.153.
10. Cunningham, p.148.
11. Cunningham, p.148.
12. Bruce Laughton, *Philip Wilson Steer*, Oxford, 1971, p.39.
13. John Barrell, *The Dark Side of the Landscape: the Rural Poor in English Painting 1730–1840*, Cambridge, 1980, pp.82–8.
14. Quoted in John Hayes, *Thomas Gainsborough*, Tate Gallery, 1980, p.38.
15. Cunningham, pp.72ff.
16. Quoted in Cunningham, p.133.
17. Quoted in Peter Coveney, *Poor Monkey, the Child in Literature*, 1957, p.57.
18. Stone, p.467.
19. Linda Pollock, *Forgotten Children: Parent-Child Relations from 1500–1900*, Cambridge, 1983, p.123.
20. Pollock, pp.199ff.

William Mulready
Train up a Child in the Way He Should Go and when He is Old He Will not Depart from It 1841
FORBES Magazine Collection, New York

Thomas Webster
The Boy with Many Friends 1841
Bury Art Gallery and Museum

Terry Atkinson
The Stone Touchers I 1985
Gimpel Fils

The End of Innocence

Joan Crossley

The Transience of Childhood

The works of art discussed in this essay all deal with the ending of childhood in either the physical or the psychological sense. Transition from child to adult can be a cause of both relief and sadness for the parent. The difficulties of adult life and the encroachment of the evils of the world are things from which the parent longs to protect the child. This stage of transition and the passage of time are recurrent preoccupations in literature and art. As an adult, the artist is able to look back and measure the transience of childhood. The preciousness of childhood is an adult invention; children long to be grown-up.

Gainsborough's Daughters, Margaret and Mary, Chasing a Butterfly (c.1756, National Gallery, illus. p. 64) is both a celebration of the child's joy in nature and a reminder of the transience of earthly pleasures, symbolised by the always uncatchable butterfly. J.E. Millais' *Bubbles* (1886, A & F Pears Ltd), arguably the most famous Victorian child painting, has a similar theme. The beautiful, shiny bubbles he blows will soon burst, as ephemeral and insubstantial as human life.

Childhood tends to be perceived as a fragile and precious time which will all too soon merge into adulthood. Grown-ups, looking back, are nostalgic for their own lost innocence and sometimes regret that they could not remain as children. The image of *Peter Pan*, 1913 (cat.56, illus. p.64), is probably so popular for this reason – he has taken the decision to run away from his destiny as a man and to stay a child forever. 'I want always to be a little boy and have fun'.[1] On one level Peter's life is ideal. He is untrammelled by unpleasant responsibilities, and is free to have adventures and to command his band of Lost Boys. The problem is that this freedom leaves him lonely and in search of the ideal mother figure who will love him and take care of him. Barrie's eternal boy encapsulates the dilemma of growing up, a special problem for men, perhaps, who may not be able to bring themselves to reject their mother and embrace the pleasures and responsibilities of adult life. Frampton's statue of Peter captures the joy and freedom of the character, the lightness that enables him to fly.

Dante Gabriel Rossetti's drawing *The Gate of Memory*, 1864 (Private Collection, U.S.A.), expresses a yearning to return to lost innocence. The painting shows a 'fallen woman' standing in a doorway. As she waits for clients, she notices a group of girls, dancing and playing games in the alley-way. The artist suggests that she is dreaming of her own girlhood, before she became a prostitute. The Pre-Raphaelite painters were particularly interested in images about the damnation or redemption of fallen women.[2] Christian texts, sometimes engraved on the frames of the pictures or printed in exhibition programmes, stress that such sinners could be saved through repentence and becoming 'as a little child again'. The girls are both a reminder of what she was and a promise of what spiritually she must become. Her imprisonment in her life of sin is suggested by gloomy city buildings. The girls playing are framed by an arch and blue sky, suggesting hope for them and for the prostitute's redemption.

The passing of time and the imminence of loss pervades a number of Victorian paintings of children. J.E. Millais' *Autumn Leaves*, 1855–6 (cat.58, illus. p.65), depicts autumn, in contrast to spring, the season which usually characterises girlhood. The opposition between the girl's youth, beauty and promise and the melancholy dying of the year gives a threatening atmosphere to the painting. As Malcom Warner points out, the apple held by the little girl on the right is 'an emblem of autumn but may also be intended to recall the Original Sin that made mankind subject to mortality.'[3] The symbolism of the Fall might also be linked to the impending loss of the girls' sexual innocence through marriage. The eyes of the two older girls stare sadly out of the picture, inviting the viewer to grieve with them.

The *momento mori* – the reminder of the inevitability of death – is present in many portraits of children. Even the joyful portrait, by Hogarth, of *The Graham Children* (cat.31) contains a tiny cupid brandishing Time's scythe. Children must use their time

wisely before it runs out.

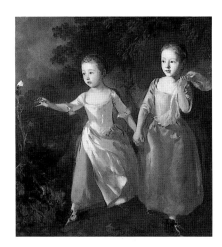

Thomas Gainsborough
Gainsborough's Daughters Chasing a Butterfly *c.*1756
Trustees of the National Gallery

George Frampton
Peter Pan 1913
Private Collection

Sir John Everett Millais
Autumn Leaves 1855-6
Manchester City Art Galleries

Carel Weight
Frightened Children 1983
Alan Yentob

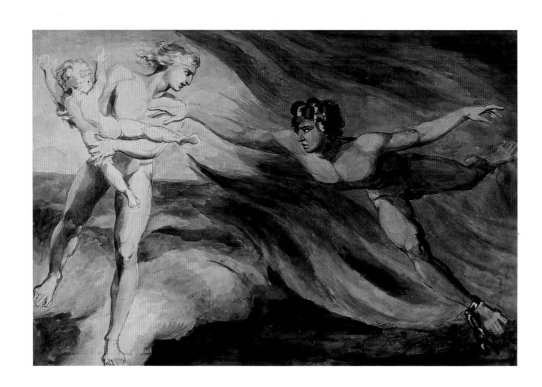

William Blake
*The Good and Evil Angels Struggling
for Possession of a Child* c.1793-4
The Trustees of the Cecil Higgins Art
Gallery, Bedford

66 The End of Innocence

Peter Howson
Blind Leading the Blind I 1991
Angela Flowers Gallery

Children at Risk

Eighteenth- and nineteenth-century art contains many allusions to childhood as ephemeral. The passing of childhood with its innocent preoccupations was poignant but natural. Twentieth-century images often show children at risk from man-made dangers like war, adult cruelty and injustice. Terry Atkinson's painting, *The Stone Touchers I*, 1985 (cat.59, illus. p.62), poses the artist's daughters in front of the grim relics of the First World War. The lines of graves reaching back through the graveyard are like lines of descent. This is the tradition, the culture, from which these girls have sprung. They are the same raw material as the people who occupy the graves, who once were uncorrupted and innocent of the desire to fight and kill. The physical vulnerability of the children with their curving bare limbs and summer holiday clothes is a poignant contrast with the rigid stone of the graves. It is a powerful statement about the futility of the Great War.

Parents are acutely aware of the vulnerability of their children to the evil of other adults. Few paintings touch on the subject of children at the mercy of cruel or perverted grown-ups, but Lowry's *Man in a Doorway* (untraced) shows a man menacing terrified small children. Carel Weight's *Frightened Children*, 1983 (cat.62, illus. p.66), shows a boy and girl bolting headlong away from some unseen danger. It is not clear whether the danger is real or one of the terrifying inventions which children love – the bogeyman which is deliciously scary and becomes almost real in their imaginations.

In recent years the ingrained belief that parents are the natural protectors of their children has been undermined by reports of sexual abuse, cruelty and neglect. Peter Howson's *Blind Leading the Blind I*, 1991 (cat.62, illus. p.67), is a terrifying image of children in danger, since their mother, drunk, stupid or mad, is blindly leading them to disaster. The mother has always been portrayed as the natural refuge for children, the wise and kind defender of the young. The children have the ravaged look of those brought prematurely into contact with grim reality.

Death

Death, or the fear of death, was an important part of child-rearing in the past. The research for this exhibition has revealed that many of the children represented in the portraits as living had actually died before the execution or completion of the work. For example, the baby in Hogarth's *The Graham Children* was dead before the painting was begun and the artist may have painted him from death-bed sketches.[4] An even higher proportion of the children depicted did not live until adulthood.[5] These sad stories reflect the high rate of infant mortality prior to the twentieth century. Poor hygiene and inadequate medical knowledge meant that one in five children died before their fifth year. Even healthy children could die terrifyingly quickly from seemingly minor ailments. Historians of childhood have debated the strategies which parents could adopt in the face of this threat. Some historians have suggested that seventeenth and eighteenth-century parents would deliberately choose not to get too close to their babies until it was clear that they would survive infancy. This view has been vigorously attacked by other historians who have produced evidence that parents loved their children even though there was a strong likelihood that the child might die in infancy.[6] Certainly there is visual evidence that some parents were moved enough by the loss of a newborn baby to wish to record his or her features. Allan Ramsay's small *Sketch of a Dead Child*, *c.*1743 (cat.54), is typical of these studies. Thought to be his eldest son, the little head is lovingly and carefully delineated. The face is composed and smiles peacefully as though in sleep. It could be argued that the act of painting, or of causing to be painted, the lost child was a way of alleviating the pain, and giving the dead one a

Allan Ramsay
Sketch of a Dead Child *c.*1743
National Galleries of Scotland

degree of visual afterlife. Modern parents who lose a newborn baby or a baby through cot-death are encouraged to photograph their dead child for similar therapeutic reasons. The function of the death-bed sketch was taken over by photography in the mid-nineteenth century when it was common practice to take dead babies to be photographed in the studio, dressed up in their best clothes. Casts of infant hands and

George Hicks
A Cloud with a Silver Lining 1980
The FORBES Magazine Collection, New York

locks of hair were also popular momentoes.

The Christian belief that children were spiritually good and innocent gave the comforting promise that the child's soul would enjoy an afterlife in Heaven. This reassurance was given artistic form in such works as George Hicks' *A Cloud with a Silver Lining* (1890, The Forbes Magazine Collection, New York), which shows an infant being welcomed into Heaven by angels. The grieving parents witness their child going to a 'better place', a silver lining to the dark cloud of their sorrow. Their clothes suggest that they are poor and that the child has been 'released' from a life of suffering and hardship. This idea was not confined to the 'sentimental' eighteenth and nineteenth centuries – there are sixteenth-century portraits where dead babies are transmuted into

guardian angels watching over their living relatives.[7] Rubens, in the mid-seventeenth century, made a sketch of the soul of a child being taken up to heaven by angels.[8]

In the nineteenth century there was an important genre of sick children paintings. In some cases the focus was the anxiety of the devoted parent or the nobility of the attendent doctor.[9] In other cases the dying child was shown as reaching a state of moral perfection which would ensure an afterlife of eternal bliss, but which also provided an exemplar for the living. It is commonly said that death has replaced sex as the taboo subject, and it is hard for twentieth-century parents to contemplate the death of children, so unusual has infant mortality become.

Innocence

In the mid-eighteenth century, when beliefs about the rational and benign nature of man became more dominant, conceptions of childhood character became more idealised. Many believed that children represented humanity in its purest form, uncorrupted by the evils of society. William Blake, artist, poet and visionary, was deeply interested in the nature of childhood. His poems for and about children, the *Songs of Innocence*, 1789 (cat.51), imply that adults could learn from children. The young in their Christ-like state of incorruption are closer to understanding the essential message of God than educated and cynical adults. Blake tries in his illustrations to recapture the child's wondering raptness at the sight of natural phenomena. The simplicity of the words and rhythms contains complex arguments on the spiritual equality of deprived children, and the nature of suffering.

William Blake's *The Good and Evil Angels Struggling for Possession of a Child*, *c.*1793–4 (cat.53, illus. p.66), has, like the *Songs of Innocence*, a range of complex readings. It is possible to interpret the child, representing all humans, as being perpetually at war with his own good and bad characteristics, or to see Good and Evil as external influences trying to possess his soul. Both these meanings would have been understood in Blake's own time. The child is at the mercy of those who care for him, for good or ill.

Alongside the belief in the essential spiritual purity of children, there developed a new 'aesthetic of childhood'. This was an appreciation of the particular beauty of children as children, untainted by such 'worldly' characteristics as wealth or rank, or their promise of masculine or feminine attractions as adults. These images examine the beauty of the child as itself, infused with its own moral and spiritual perfection. Reynolds' sketches of Miss Frances Isabella Gordon, exhibited at the Royal Academy in 1787 as *Angels' Heads* (cat.55, illus. p.77), celebrate the babyish features, the wide eyes and the gentleness of the facial contours. The depiction of her as an angel explicitly reminds us of the idealisation of children and the long tradition of putti and cherubim being represented in art as babies. In Renaissance paintings the human soul was sometimes shown as a baby. Reynolds' painting, *The Age of Innocence* (*c.*1788, Plymouth City Museum and Art Gallery), represents his own great-niece as an icon of unsullied purity. The symbols of her moral and spiritual innocence are the white dress and her unbound hair which explicitly equate her with Nature and the uncorrupted rural landscape.

The idealisation of female children, as pure women in the making, was developed in the Victorian period, perhaps most obsessively by Thomas Cooper Gotch. Gotch believed in the high moral nature of Woman. His style was influenced by Italian fifteenth-century religious painting; his beautiful, long-haired, big-eyed girls in early adolescence are secular female saints, sometimes enthroned or singing angelically.

In nineteenth-century art and literature the angel-child becomes actively engaged in trying to save adults from their sins. The 'morally redemptive child' has many manifestations, as the little girl in the popular song who begs her Daddy not to go to the pub again, and as the daughter who tries to protect her father from the consequences of

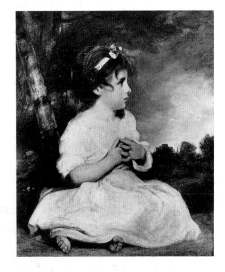

Sir Joshua Reynolds
The Age of Innocence *c.*1788
Reproduced by permission of Plymouth
City Museums and Art Gallery

Thomas Gotch
The Child Enthroned 1894
The Fine Art Society, London

his poaching. In Rebecca Solomon's painting *The Lion and the Mouse or Sweet Mercy is Nobility's True Badge* (1865, Geffrye Museum), a small blond girl finds the courage to plead for the life of a sailor lad caught poaching on her family estate. The etching (possibly depicting Christ and the Woman of Samaria) behind her head shows the source of her moral and spiritual inspiration and reminds us of the wealth of child-based

Peter Blake
Daimler 1980
The Jaguar Daimler Heritage Trust

72 The End of Innocence

Gilbert and George
BERRYBOY 1984
Private Collection

texts in Christian teaching. Her combination of feminine helplessness, innocence and courage will touch the heart of her just but stern grandparent.

The child-angel is not a popular image in the twentieth century, except in washing-up liquid advertisements. Excessive goodness in children is seen as being the result of too repressive discipline, and bad for the child's development. Naughtiness is preferred, since it is interpreted as showing spirit, humour and individuality. Richmel Crompton's *Just William* is a distinctively twentieth-century hero – in Victorian literature he would have been doomed to retribution and possibly a painful death.

Children and Sexuality

In the late twentieth century we speak openly as never before about the vulnerability of children to sexual exploitation by adults. One of the most shocking aspects of child sex abuse is that we consider children to be naturally antithetical to sex. Sexual experience is something we must protect them from until they are old enough to understand fully and to participate as consenting adults. The sexual abuse of children has a long history. In the same era that some adults venerated the holy innocence of the ideal child, there was widespread trade in the prostituted bodies of working-class children. In the mid-nineteenth century child prostitutes as young as nine were being hawked on the streets of London. The fear of venereal disease made men seek out young girls in the hope that they might not yet have been infected.

In the nineteenth century there were a number of artists who specialised in portraits of very young female and male bodies. It would be too crude to suggest that every image of a naked child must have been executed by a paedophile. Children's bodies are very beautiful, and seem untouched and unscarred compared with those of adults. Some images, however, do present the pubescent or pre-pubescent child to us in an overtly provocative manner. But to interpret them as sexual at once compromises the viewer. One side-effect of the publicity surrounding incestuous child abuse is the loss of the average parent's innocence on the subject.

Gerald Brockhurst
Adolescence 1932
Trustees of the British Museum

Youth and innocence were highly admired in women in the Victorian era. Child-like qualities were seen as denoting sweetness and virtue. But admiration of child-likeness could displace sexual attraction to womanly qualities. 'The lines of sexuality, both in real life and art, blurred between the child-woman and the woman-child. What was womanly about the girl thus had visual and sexual appeal, and conversely, what was girlish about the woman was both socially encouraged and enticing, especially her purity, vulnerability, ingenuousness and devotion.'[10] In an age that found overt sexuality and maturity unattractive in women, it was inevitable that the admired girlishness would be found in genuine little girls. John Ruskin, the critic and artist, fell in love with Rose La Touche when she was nearly ten and he was forty. His feelings for her displaced any love for adult women and he waited seven years to propose marriage to her.[11] The admiration of Charles Dodgson, alias Lewis Carroll, for Alice and other little girls, of whom he enjoyed taking nude photographs, was at least tinged with sexuality. Many painters produced images of children or adolescents which were imbued, perhaps unconsciously, with sexual invitation which seems blatant only to late twentieth-century eyes.

Gerald Brockhurst's *Adolescence*, 1932 (cat.65), shows a young girl staring at her naked body in the mirror. It is a reworking of a Renaissance genre; the woman admiring her own beauty is shown to be vain and worthless, whilst displaying her body for the (male) viewer. The setting is not a generalised boudoir with drapery and putti, but a realistically recorded 1930s interior. The girl is very young and has the slight, unformed look of a girl in her early teens. We do not feel that hers is mere curiosity, and certainly not narcissism. Her gaze is sad and her mouth is tense. Perhaps we are meant to conclude that she is suffering from the fear of womanhood attributed to girls by male

Simeon Solomon
Love among the Schoolboys 1865
Private Collection

artists such as Gotch. The artist used his lover, who was twenty, as a model – at such an age she definitely was not adolescent, so we must speculate upon the artist's interest in this phase of developing female sexuality. While we are clearly invited by the artist to enter the girl's inner life, we are also allowed to enjoy her as a beautiful object. The bare neck and tied up hair leave her vulnerable and exposed to our gaze. We feel that we are looking at a private moment, seeing something that we should not really see. Our gaze is thus potentially prurient.

Peter Blake's fantasy picture *Daimler*, 1980 (cat.66, illus. p.72), places very young naked girls in a landscape setting. The girls range from the overtly alluring to the slightly grotesque. Their presence in the field is unexplained, unless it implies some kind of worship of the shiny car. Cars, especially expensive, powerful cars, are associated with the phallus and male sexuality. The car is disproportionately large, its metallic surface pushes coldly into the pictorial space, contrasting with the watchful passivity of the girls in the middle ground. A huge full moon, which often symbolizes the feminine principle, floats overhead. Blake is here self-consciously taking motifs from Victorian fairy paintings, with their strange, erotic depictions of girls as fairies.

The representation of the young male nude is a tradition in Western art stretching back beyond the Greek Kouros. The strength of this tradition makes it debateable whether some images are intentionally homo-erotic. The artist H.S. Tuke, who specialised in beach scenes with naked adolescents, enjoyed considerable popularity with homosexual patrons.[12] Tuke's boys disport themselves on sunlit beaches, deliberately recalling the young men taking part in sports from Greek art. In doing so, they display their bodies in an apparently artless manner.

Simeon Solomon's *Love among the Schoolboys*, 1865 (cat.67), shows a group of very young and older boys at a public school. Friendships between men, as boys and in adult life, were encouraged as being a higher, more disinterested, form of love than that between men and women. That some of these friendships had a sexual basis could not be openly acknowledged for fear of prosecution. One of Solomon's friends, Oscar Browning, was dismissed from his post at Eton after a love-affair with a pupil. The artist himself was disgraced after a sexual scandal, his career ruined. The drawing is a rare

surviving example of a type of work which would have been executed only for private viewing. The connotations of the work are undoubtedly erotic, with emphasis on the beauty of the curly-haired, wide-eyed young boys, in their romantic ruffled shirts and knee-breeches, and their seduction by the older boys. This drawing, which may have been made to illustrate one of Swinburne's stories about flagellation, once belonged to Oscar Wilde.

Gilbert and George's *BERRYBOY*, 1984 (cat.68, illus. p.73), depicts a teenage boy. The sexual aspect of the work is defused by the overtly religious iconography. The placing of the figure, the use of black outlines and bright colours recall stained glass windows. The beautiful boy is a kind of saint-hero figure dominating the image. He is surrounded though by ripe fruits, implying that he too is a commodity to be consumed.

Such images of provocative children are disturbing because they disrupt the distance we have placed between children and sexual desire. The legal age barrier between children and sexual experience has frequently been changed, reminding us that the category of child is not fixed and self-evident. At present, sixteen is the age at which girls can legally commence sexual activity, but the age of consent for homosexual males remains at twenty-one. In the nineteenth century, the age of consent for girls was only twelve, although the average age of menarche was much later than it is today. Legal independence from parents could take effect at twenty-one or twenty-five, for men, and in the case of women, not at all. Women remained the property of their parents until they became the property of their husbands.

Marriage could take place as early as the parents chose, although child marriages were increasingly frowned upon from the late seventeenth century. Marriage between working and middle-class couples was often delayed until the late twenties or thirties, when the husband might have finished his apprenticeship or reached another kind of financial security. Where great possessions were at stake, marriage could be contracted between babies, with sexual consummation to take place at a later date. *Lady Charlotte Fitzroy*, c.1672 (cat.63, illus. p.78), was painted to mark her betrothal to Sir Edward Lee. Charlotte was the fourth child of the Duchess of Cleveland by the King, Charles II. Considerable wealth was bestowed on her husband on the occasion of their marriage, including the Earldom of Lichfield. The betrothal was much more than a contract between an eight-year-old girl and a ten or eleven-year-old boy. It was the tying up of land, houses, money, titles and influence. The portrait celebrates the individual as an indirect compliment to those who bestow and those who receive her.

The other child in the picture, the Indian boy, is her antithesis in race, gender and rank. He was, presumably, an actual servant of the Duchess of Cleveland. His refined dark, masculine beauty is a perfect foil for her fair loveliness. The picture proclaims her beauty in a pose which parodies Van Dyck's court beauty portraits – she is depicted as a little woman, despite her extreme youth. It is this quality as well as her financial backing which the betrothal portrait is selling. After the marriage, Charlotte was sent to a convent in France, until she was considered old enough for the marriage to be consummated.

Philippe Ariès produced evidence of a more open attitude to the child's body and sexual experimentation in the sixteenth and seventeenth centuries. Ariès pointed out that 'the liberties which people took with children …the coarseness of the jokes they made and the indecency of gestures made in public' surprise and shock the modern reader. The chronicle of the first five years of Louis XIII's life records lewd games, and references to the child's future sexual activity, which the Court reportedly found hilarious.[13] After the age of seven this playful learning about the body was expected to be replaced with adult reserve and decorum.

Victorian and twentieth-century art has many examples, such as that of Dodgson's photograph's and Tuke's paintings which exploit children for the sexual pleasure of adults. Works of art which deal with the sexual desire of the young for one another are much rarer. Sex and love which did not have the adult sanction of marriage was

uncontrolled and disruptive to social order. Foucault has shown that the sexual control of the working classes was a dominant concern in Victorian society.[14] Smallfield's *Early Lovers*, *c*.1859 (cat.64, illus. p.79), is a Victorian version of the traditional theme of lovers in Arcady. The depiction of amorous young people without a chaperone was problematic for mid-nineteenth-century audiences, since it suggested sexual immorality. Smallfield negotiated the potentially disturbing connotations of the subject by placing the lovers in a rural setting. Such a tryst, without a chaperone, would have had much more sinister connotations if set among the wickedness of London streets instead of what was believed to be the uncorrupted innocence of the country. The romantic rather than the physical nature of their love is reinforced by the sturdy fence, which separates their bodies. With these reassurances about the purity of the relationship, it was possible for Smallfield's audience to admire the pure devotion of the peasant lovers.

Sir Joshua Reynolds
*A Child's Portrait in Different Views:
'Angels' Heads'* 1786-7
Tate Gallery

1. J.M.Barrie, *Peter Pan* 1904, Act I, Sc. ii.
2. Lynda Nead, *Myths of Sexuality*, Oxford, 1988.
3. *The Pre-Raphaelites*, Tate Gallery, 1984, p.139.
4. Mary Webster, 'An Eighteenth Century Family: Hogarth's Portrait of the Graham Children' *Apollo*, CXXX, no.31, Sept. 1989, pp.171–173.
5. Princess Anne, the baby in *Five Children of Charles I* died shortly after the painting was completed. The seraphic Frances Gordon, whose portrait as *Angels' Heads* was painted by Reynolds, died at the age of nine. Oliver Madox Brown died while still in his late teens.
6. Philippe Ariès, *Centuries of Childhood*, 1962.
 Lawrence Stone, *The Family, Sex and Marriage*, 1977.
7. W. van de Passe, *The Family of James I*, *c*.1622–4, British Museum.
8. Ashmolean Museum, Oxford.
9. Luke Fildes' *The Doctor* (Tate Gallery) and Frances Farmer's *An Anxious Hour* (Victoria and Albert Museum) are example of sick children being cared for by devoted adults.
10. Susan P. Casteras, *Images of Victorian Womanhood in English Art*, London & Toronto, 1987, p.40.
11. Joan Evans, *John Ruskin*, 1954, p.263.
12. Emmanuel Cooper, *The Life and Work of Henry Scott Tuke*, 1987.
13. Ariès, see especially Chapter Five 'From Immodesty to Innocence'
14. M. Foucault, *History of Sexuality*, vol. 1, trans. R. Hurley, 1978.

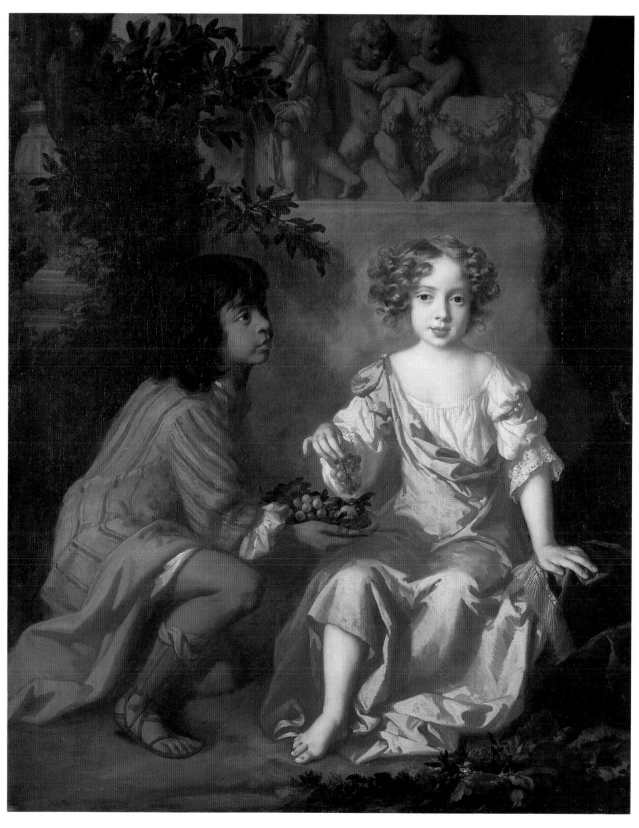

Sir Peter Lely
Lady Charlotte Fitzroy *c.*1672
York City Art Gallery

78 The End of Innocence

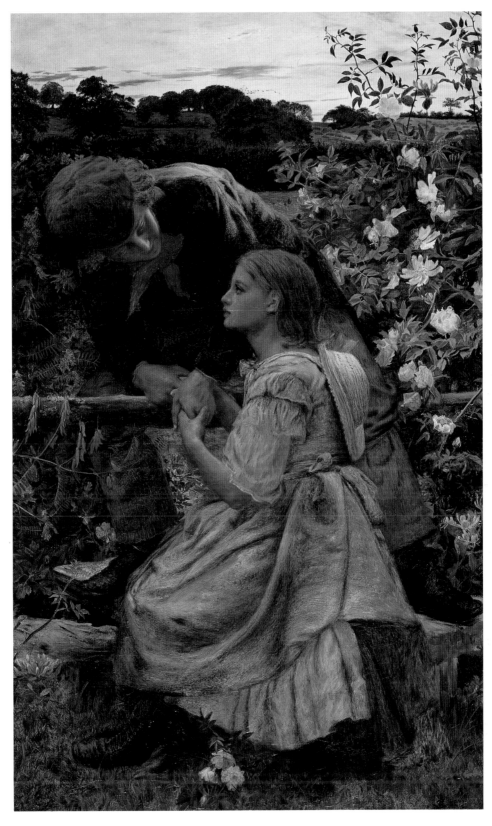

Frederick Smallfield
Early Lovers *c.* 1859
Manchester City Art Galleries

Augustus John
Robin 1911
Private Collection c/o Anthony Mould
Ltd

Looking at Children

Christina Hardyment

The History of Childhood 1600 to the Present

I am called chyldhod; in play is all my mind,
To cast a coyte, a cokstele, and a ball.
A toppe can I set, and dryve it in his kynde,
But would to god these hatefull books all
Were in a fyre brent to pouder small.
That myght I lede my lyfe always in play.
 Sir Thomas More

The child conjured up by Sir Thomas More's verse would appear to fit easily enough into the average playground today. But there were important differences between him and his modern counterpart. Four hundred years ago children were much more part of everyday adult life than they are now. Instead of being sent to school between the ages of five and sixteen, they were an essential part of the work force both inside and outside the home. The legal age of marriage was twelve for girls and fourteen for boys, and at this age they had a right to their own earnings and to make wills, although until the age of twenty-one they were still legally defined as children. Do these basic facts mean that the experience of childhood in the past was qualitatively different from that of the present?

Generalising about childhood is fraught with risk: the prince and the pauper seem to have little enough in common, and at any one time, in the past as in the present, we can read of parents as both perverted tyrants and angels in the house. Taking their cue from Philippe Ariès *Centuries of Childhood* (1960), many historians in the last thirty years have claimed that childhood in the past was a lesser state; that children were physically abused in life and unlamented in death until a turning point in emotional sensiblity which they pin more or less exactly to the eighteenth century. Lawrence Stone believed that high infant mortality made Tudor and Stuart parents fairly indifferent to the births and deaths of their children, giving as evidence such practices as swaddling and wet-nurses. Sir John Plumb contrasted the 'coldness and callousness' of seventeenth-century parents with the 'new world' of the eighteenth century, when parents took real pleasure in dressing, playing with and providing toys for their children. The most extreme claims were made by the psychoanalytically-orientated American historian Lloyd de Mause in his 1976 essay on the evolution of childhood,[1] in which he portrays the history of childhood as virtually synonymous with the history of child abuse.

In the last decade these attitudes have been criticised and amended. Demographers and economic historians such as Michael Anderson and Alan MacFarlane have pointed to the influence of regional and occupational factors on the lot of children. Ralph Houlbrooke's *The English Family 1450–1700* (1984) offers evidence for deep parental concern and interest in children's development and well-being. This is echoed in *Forgotten Children* (1983), Linda Pollock's close analysis of hundreds of little known diaries and autobiographies. What the diaries do reveal, she points out, is the growth and spread of literacy in the eighteenth century, and increased expertise with writing as a form of communication. She suggests that it was this growing ability to express abstract ideals rather than a qualitatively different attitude to children which created an apparent growth in sensibility. Most parents 'have always tried to do their best for their children within the context of their culture.' It is essential to bear in mind, she adds, that 'children were and remain children of their place, class and time, subject to the same living conditions as adults of their society'.

Pollock's conclusions are reinforced by a study of childcare manuals. Obviously, these will often offer an ideal way of rearing children rather than a systematic account of how children were actually brought up, but treated with care they are important sources, particularly if we bear in mind Mrs Gaskell's despairing observation about advice on childcare in her delightful 1840s diary of her little daughter Marianne: 'The books do so

differ!' Taken in the mass (and after the development of cheap printing methods in the early nineteenth century, they certainly were *en masse*), they frame an enormous diversity of individual methods of handling children in the context of the prevailing thinking of the period. But from the earliest (Thomas Phaire's *The Boke of Chyldren*) to the most modern (Michael Rosen's *Goodies and Daddies, A Father's Guide to Bringing-up Children*), they reflect love and concern.

Both these sources convey on the whole only the experiences that the literate middle-class parent has committed to paper. We have still little evidence concerning the children of the illiterate mass of the population, only the records of the exceptional cases, what one could call the pathology of parenting, which came before church and county courts, coroners' inquests, and other judicial proceedings. Much needs to be done to broaden the picture, and happily much is happening. At the Bethnal Green Museum of Childhood there are exciting plans to create galleries which will gather together an enormously wide range of material evidence concerning 'the history of growing up', and in recent years a boom in amateur research into family history is beginning to compensate for the one-sided nature of the official record by providing hundreds of thousands of personal biographies. In time, as these are collated and compared, we will know much more about childhood in the past. We may be getting closer to what Keith Thomas has called for in an illuminating essay on children in early modern England:[2] a history of childhood, rather than a history of adult attitudes to children.

The images of childhood created by artists which form the body of this exhibition are important historical evidence in this context, although they too show the child as seen by the adult. Some are mere records of achievement (formal portraits, tombstone effigies), some are officially commisssioned presentations of perfection, some are tracts for the times intended to have a hard-hitting social message. Occasionally too, there are painters who depict everyday realities, but we have to allow for their individual quirks before assuming they are recording actuality. The experience of childhood past or present, as felt by children when children, rather than just by the child who remains in the heart of the adult, is more elusive. When researchers at the University of Surrey wanted to find out how children felt about the threat of nuclear war, they asked them to draw pictures. The result was a compendium of nightmare visions that shocked everyone concerned with the project.

We all know how little of the realities of our lives, either as children or as parents, we have placed on the record. A few children's diaries do survive, but they tend to be those of prodigies, and to be written with more than half an eye to an adult reader. I suspect that personal experience of bringing up children may be as useful in constructing an accurate history of childhood as demographic number-crunching using incomplete statistics or the woefully inadequate written evidence. At least it avoids nonsensical assertions that may well tell us more about the childhood of the historian concerned than of the child in history.

My own conclusion is certainly not that nothing has changed as far as childhood is concerned, but that what changes we can observe are reflections of wider social trends that have also affected adult experience, rather than symptoms of some peculiar and independent history of the emotions. This essay will focus on the most tangible of those changes – the improvement in children's health, the balance between work and play in their lives, the spread of institutional education, and the effect of the new technology of the twentieth century on the family group – and will indicate how such changes affected relations between parent and child, and between the child and the outside world.

In 1590, the infant's first challenge was staying alive. Many mothers, physically feeble from many pregnancies, and living on insufficiently nourishing diets, were unable to breast feed, and bringing up 'by hand' was described by one early eighteenth-century authority as 'a lottery in which there are a hundred blanks for one prize'. Animal milk

was distrusted, perhaps rightly before pasteurization and refrigeration could keep it fresh and uncontaminated, and pap, the flour and water mixture commonly fed to small babies, was in the opinion of the same expert, 'more proper to bind books than for the nourishment of infants'. As late as 1904, death rates for infants in Salford ranged from 128.6 per 1000 for those breastfed, to 163.9 per 1000 for those fed on cow's milk and 439 per 1000 for those fed on other foods, such as condensed milk.[3]

The safest alternative was a wet-nurse, perhaps a female relative with milk to spare, or, if the family could afford it, a hired girl from the country. For some (but by no means all) in the prosperous classes, a wet-nurse was a choice rather than a necessity, a parallel to the many mothers today who prefer to bottlefeed. Great pains were taken to find a satisfactory nurse, since it was believed that the child drank in the foster-nurse's character with her milk. James I's wife Queen Anne, who insisted on feeding her own babies, declared 'Would I let my child, the child of a king, suck the milk of a servant, and mingle the royal blood with the blood of a servant?'[4]

The first moves towards successful artificial feeding for babies were when scientific analysis of breast milk made 'formula-feeding' fashionable. By 1900, chemical analysis created 'modified milk' by diluting cow's milk to reduce the casein, adding cream to increase fat and lactose to sweeten it. More important to the infant's health was the realisation that bacteria bred freely in the old fashioned feeding bottles. Simple, easily cleaned bottles and careful sterilizing contributed as much as the constituents of the food to a bottle-fed baby's health.

Inadequate feeding was not the only threat to a child. Without antibiotics a childish cough could turn into a fatal case of pneumonia. Serious infectious diseases such as smallpox were inescapable hazards until vaccination (first discovered at the end of the eighteenth century) and innoculation were developed. But urban life remained a hazard for small children before sanitary developments in the mid nineteenth century reduced the risk of epidemic diseases. Families who could afford to do so often sent delicate children away from the town to be nursed because they stood a better chance of survival.

It was not until after the First World War that the combined forces of improved nutrition, medical advances, education and social welfare provision reduced the rate of infant mortality in the industrial heartlands of Britain. Death, then, was an everyday experience of infancy. As children grew older, they continued to be at risk, both from disease and from the everyday hazards of their working lives. Coroners' records reflect the separate worlds of boys and girls. Boys meet with accidents out of doors, girls within: a ten year old farmboy cuts himself on a rusty ploughshare, a little girl helping in the kitchen is scalded to death by a cauldron tumbling from its trivet.

But the frequency of children dying was more than offset by the number born. The most remarkable demographic difference between childhood in the past and the present is the proportion of young to old people. Keith Thomas has calculated that 30% of the population in the late seventeenth century was under fifteen. 'Children,' he declares, 'were ubiquitous.'[5] There were far more around in proportion to adults than there are today. Life expectany for their parents averaged forty-five years, so many were destined to be orphans and vagabonds, running wild around the streets of the growing towns.

Today only around 18% of the population is under fifteen, and a growing number are over sixty. We can hope to live to seventy-two if we are men, seventy-eight if we are women. A twenty-four-year-old bride in 1750 could expect to spend all her married life (twenty-eight years on average) having babies and children under twelve underfoot. In 1980, her childbearing and caring days are limited to fourteen on average: she is likely to have three to four decades of her adult life free to live a life of her own.

As the proud parades in seventeenth-century portraits reflect, babies and small children constituted a larger and longer-lasting presence in family life than the brief and transitory episode they fill in adult lives today. Parents were more likely to have

experienced the infancy of their own siblings and kin while they were teenagers, and to be correspondingly more confident in handling their own babies.

Many aspects of childcare in early modern times that seem misguided by modern lights make sense in the context of the age. Take swaddling. Seen by some historians of childhood as a form of imprisonment ruthlessly imposed on babies for the convenience of their handlers, in fact it had its merits in a draughty and dangerous age. The newborn baby was safe from open fires and animals. Moreover, swaddling is soothing: it slows down the heartbeat and encourages calm.

Older infants were altogether more likely to be 'babes-in-arms' than they are today. Wheeled perambulators were not a feasible proposition until the mid-nineteenth century, when improved pavements and india-rubber tyres made them reasonably comfortable. A special nurse called a 'rocker' was employed in prosperous families. William Cadogan, an eighteenth-century paediatrician, summed up the main business of a nurse as 'to keep the child sweet and clean, and to tumble and toss it about a good deal, play with it, and keep it in a good humour'.

Toddlers were protected by 'little pens made of leather'. When set on wheels they were known as 'go-gins', 'going-stools' or 'babyrunners'. These more or less elegant wooden frames, not very different from modern babywalkers, can be seen in medieval woodcuts and later illustrations on domestic themes. A Giulio Romano drawing of the Holy Family at Chatsworth shows Joseph the carpenter offering a square wooden frame on wheels to the infant Jesus.

As houses became warmer and safer, with glass in their windows, water on tap, and iron ranges rather than open hearths, children's domestic freedom increased. The growth of cities, on the other hand, made the outside world a more dangerous place. The increase in wheeled traffic, first horsedrawn, later motorised, has transformed the streets which were children's natural playground and in which they once learned about the workings of the adult world. Areas began to be set aside for juvenile recreation, heralding the separate world which children occupy in our society today.

Children's lives in early modern times, and earlier, seem to have involved a respectable admixture of sheer fun and games. Hoops and tops, rattles and windmills have been spun and waved by children right across the centuries. Toys for boys and toys for girls were clearly defined, although then as now there were no doubt exceptions to the rule, a gradation of gender preferences rather than an absolute divide. Boys wore skirts, until they 'took their degree in knickerbockers' at around the age of three or four, but their chosen toys were the trumpets, drums and (hobby) horses of war. Nor is criticism of such activities in the interests of pacifism a modern idea: Thomas Tryon's *New Method of Educating Children* (1695) advocated banning all war games because they encouraged aggression. Girls had their dolls, made from a clothes-peg and rags, or an exquisite miniature clothed by a dressmaker to show milady the latest Paris fashions, and then begged by her daughter as a moppet. They were cared for tenderly, given make-believe birth, marriage and even burial[6] – a slightly macabre reflection of the familiarity of these children with death.

Toys such as these were props with which children playfully practised adult pursuits, but the capacity for toys to be more directly educational has long been appreciated. In her 1789 *Practical Education*, Maria Edgeworth suggested that 'rational toyshops' be set up, 'stocked with sturdy carts, small gardening tools, printing presses, looms, and furniture which takes to pieces and reassembles'. She also described ideas for the nursery which could have been taken straight from a modern Early Learning catalogue: jigsaws, scale models of houses, sets of wooden and ivory sticks of different sizes which a child could be taught to fit through squares, circles and triangles of wood with holes in them.

Victorian children were not necessarily kept as strictly under control as popular set-piece paintings suggest. 'The parlour looks like Bedlam at the present moment, strewn with bricks, dominoes and picture books', wrote Hannah Allen in her 1840s diary.

William Hogarth
The First Stage of Cruelty 1751
Trustees of the British Museum

'Archie [aged 6] is lying on the hearth kicking up his heels while he harnesses his donkey; babie Alfie [2½] has found an old doll's head minus the trunk, and is loving and kissing it most amusingly ... Edie [7] has just come in from the garden with glowing cheeks to show me a treasure of fifteen violets in a sunny corner'.[7]

As industries developed, children's playthings became machine-made rather than handmade, cheaper and more widely accessible. Mass production and middle-class prosperity, rather than a sudden access of parental generosity, explains the huge increase in surviving evidence of children's playthings in the nineteenth century. In recent years a strong element of fantasy can be found in popular toys, a reflection perhaps of the lack of a clear path towards following a parent's occupation. Often linked to television cartoons, they offer role-playing of an idealised sort, be it Barbie's Hawaian Holiday or Thunderbirds' interstellar warfare.

Pets are another recurring constant as children's companions: birds, cats, above all dogs, whether scraggy mongrels, coddled lapdogs or great mastiffs. Pictorial evidence suggests that they were given much more freedom in houses and gardens than our own

hutched captives: few family portraits were thought complete without at least a cat, a dog, or a bird, often all three. Hogarth's engravings show 'The Tyrant in the Boy', the darker side of children left undisciplined to experiment with life and death, but he also provides the option of pity, the 'Youth of Gentler Heart' who tries to save the tortured animals by bartering his tart.

Unruly adolescents are far from being a late twentieth-century phenomenon – rather, young people may be returning to a traditional insubordination only driven underground between 1914 and 1946 by the experience of two world wars and a great depression. In 1595 the choristers of St Paul's were indicted for 'pissing upon stones in the Churche ... to slide upon, as uppon ysse',[8] and gangs of children roamed the streets of cities, throwing stones at passing coaches and at windows. Keith Thomas has defined the essential attributes of their subculture in terms that could be taken from a modern magistrate's summing-up: 'a casual attitude to private property, an addiction to mischief, and a predilection for what most adults regarded as noise and dirt.'

For all this chaos at the fringes of polite life, education and socialization were taken very seriously in the seventeeth century, but it was emphatically a matter for parents, rather than the individual child or a school teacher to decide on its future. 'Let parents choose betimes the vocations and courses they mean their children should take' advised Francis Bacon, 'for then they are most flexible; and let them not too much apply themselves to the disposition of their children, as thinking they will take best to that which they have a mind to.'[9] First the mother taught the toddler to read and pray, later the father took over the responsibility of lessons which introduced children to the realities of their social setting. If his wage-earning occupation separated a father from the domestic unit, this role might be more or less intermittent, but in the eighteenth and nineteenth centuries it remained at the backbone of family life.

In all classes, as soon as children could be usefully employed, they were applied to sewing seams, weeding vegetable beds, rocking cradles, waiting at table. At the age of seven, most working-class children were earning 2d or 3d a day. Between 1574 and 1821 some 60% of the population aged between fifteen and twenty-four left home to serve in someone else's home or farm, to follow an apprenticeship or to work and live in another household as a journeyman.[10] The point of the exodus was not uncaringness but a combination of economic need and opportunity. At one time in a family's life cycle it would need domestic help (for example, when there were a great many small children, some of whom could be handicapped or chronically ill), at others it could provide labour: strapping teenagers could be sent to earn good money and find their way in the world. Children who didn't leave often worked in their own homes for wages paid by their parents. The will of a Stockport weaver, Alexander Daniel, recorded debts of 3s 6d, 6s and 12s 5d to three of his sons.

Even in aristocratic circles, where children were better educated and more strictly disciplined, it was a common practice to send children as young as nine or ten away for a period to serve in the households of other families, just as they are sent away today to boarding schools. But they learned social and domestic skills rather than embarking on a course of individual intellectual improvement. Such manuals of manners as the fifteenth-century *Babees Book* or Hollybrand's lively Elizabethan *Dialogues* gave these children instructions which are full of illuminating details of everyday life.

> Why have you not covered with the table-cloth & napkins of damask? ... Go fetch another basin and Ewer for these two be too few for us all to wash in and see that every basin has its towell ... Is the pepper boxe on the table? See that the little silver bottle be full of Vinegar of Roses.

They might also meet a future spouse. The great Elizabethan termagant Bess of Hardwick, the richest woman in England barring the Queen, met the first of her four husbands when she was attached to the household of family friends in her teens.

But for most of the population, marriage, although legal at twelve for girls and

H.C. Bryant (circle of)
The Lowther Arcade *c.*1870
Coutts & Co

Cover:
Mark Symons
The Day after Christmas 1931
Bury Art Gallery and Museum

Carel Weight
The Silence 1965
Royal Academy of Arts

Joan Eardley
Little Girl with a Squint 1962
Dumfriesshire Educational Trust,
Gracefield Arts Centre

fourteen for boys, tended to be put off until the late twenties for economic reasons, a state of affairs which remained true until well into the nineteenth century. Until young people held property or became married, they lived a life of happy irresponsibility which John Gillis has described as 'polygamous innocence'.[11] It was punctuated by such community celebrations, part pagan, part religious, as Twelfth Night, St Valentine's Day, May Day, Oak Apple Day, Hallowe'en and Gunpowder Treason Day. Besides these, hiring fairs and weekly markets, election days and national victories were all excuses for partying. Girls seem to have had considerable freedom, and pregnancy was quite often the trigger for a marriage.

What of discipline? There was certainly a degree of physical severity in correction for mistakes and wrongdoings which today we find shocking to imagine being applied to small children. But we also find it shocking that a man caught stealing a sheep or a woman who abandoned her baby could be hanged. In the context of the social world children were growing up in, it was felt to be important that they learnt the severity of the penalties attached to wrongdoing – the wages of sin, remember, were still, quite literally, death. Mrs Sherwood's *Fairchild Family*, a popular moral tale of the early nineteenth century, has an episode in which the squabbling siblings are taken to inspect the local gibbet; later the children are threatened with damnation for stealing an apple. There was also, at least among some religious groups, a sense of urgency lest the child, born a limb of Satan imbued with original sin, be condemned to everlasting damnation by dying young.

Smacks and canings were undoubtedly a commonplace of childrearing, but there has always been evidence of disapproval of savage whippings, an echo, perhaps, of moves to mitigate the severity of corporal punishments for adults. 'A coarse, clamorous method of enforcing obedience is to be avoided,' wrote James Nelson in his 1750 *Essay on Government*, a little book on 'the whole of a parent's care for their offspring'. 'Severe and frequent whipping is, I think, a very bad practice; it inflames the skin, puts the blood in a ferment, and there is besides a meanness, a degree of ignominy attending it.'

Just as powerful a means of disciplining as the rod was psychological manipulation by the use of guilt, something which began to supersede corporal punishment early in the nineteenth century. Conscience was 'the greatest and noblest of the moral powers of man' declared William Alcott in his *Young Mother's Assistant* of 1824, and a regard for it should be instilled very early. Phrenologists writing at this time identified it as a physical part of the brain which could be nurtured by upbringing. Wesleyan Methodism had swept the country at the turn of the eighteenth century, forcing the Church of England to put what had become something of a tumbled house into order, and bringing a religious revival which brought to the fore the Christian model of the Holy Family. Whether this was a reflection of a gradual shift in domestic authority towards mothers and away from fathers would be hard to prove, but manuals on childcare were certainly increasingly often addressed to mothers rather than parents. 'Mothers!' wrote Lydia Sigourney in 1838, 'If there is one grave in the churchyard shorter than your child, hasten to instruct him in religion.'

James Casey (*The History of the Family*, 1989) believes that 'modernisation seems to have brought with it a greater, not a lesser disciplining of the young. It is no less real for being subtle and informal, and those who cannot accept it are marginalised as hooligans.' The conduit for such discipline is full-time education. One of the most profound alterations in the relation of children to society over the last one hundred and fifty years has been the gradual replacement of piecemeal and short-term parish education, which bolstered parental authority and the child's integration into the church community, by full-time state education, which promotes individual achievement, and encourages children to look outwards towards a wide range of life choices unconnected with their family background.

Until the Education Art of 1870, formal schooling played little part in the life of most children. In Lancashire and Cheshire in the 1620s, there were only around seventy-five

teachers, one for every 2,600 inhabitants.[12] Around 90% of children at any one time were not attending school, though many would have had a brief encounter with education at some point. Philanthropically endowed grammar schools, Sunday schools, ragged schools, and dame schools organised by the parish provided an uneven patchwork of learning opportunities.

Once the Factory Act of 1833 began the long process of protecting children by law from exploitation in the nascent industries by banning children under nine from working in textile mills other than silk, there was an increased demand for schools, not least to reduce the positive nuisance of children roaming the streets unsupervised because necessity forced both their parents to be out at work. It should be borne in mind that one advantage of children working in factories was that their parents worked there too, and so could keep an eye on them. Many parents complained that the Factory Acts could make life more rather than less dangerous for children. In 1893 the working age for all children was raised to eleven, in 1902 to twelve, in 1918 to fourteen, in 1944 to fifteen, and finally to sixteen in 1973.

The influence of universal schooling on changes in family style from the interdependent group to the collection of individuals housed under one roof has been both powerful and largely unrecognised. Since the Second World War, school has become an increasingly important part of a child's life, dominating evenings with homework and effectively ending the old habits of juvenile contributions to domestic management. The ethic of educating has also changed. From being harshly disciplinarian, it has gradually adopted the gentleness of domestic life. Influential educators such as Pestalozzi, Froebel and Montessori stressed the need for teachers to educate by kindness and sympathy, to behave, in short, as substitute parents. The scope of school curricula has broadened from teaching the traditional 'three R's' to providing the sort of broad introduction to the world which was once seen as the responsibility of fathers. Insistence on school uniform for children of all ages was intended to convey group solidarity and equal opportunity, a striking symbol of the pressure to conform to the values of the peer group and the outside world rather than those of the child's individual family circle.

A recent and potentially even more revolutionary influence on children's education in the broadest sense has been the power of the media. The outward-looking eye of the television set and the inward-turning ear of their personal stereo distract them from family life, create individual, often quite unrealistic life ambitions which reject parental precedents, and unite them with their peers across class and distance. As children reach teenage, they tend increasingly to identify with each other rather than family or school. At this age, uniform seems irrelevant and most sixth-forms have discarded it. But another sort of uniform, that dictated by the changing fashions of the moment, continues to give these 'young adults' the security they seek as they grope towards a new independent identity.

Another significant change in children's lives has been the reduction in the numbers of siblings and kin. Contraception began to be widely and increasingly efficiently practised in the twentieth century, thanks to such public information campaigns as those launched by Annie Besant and Charles Bradlaugh in the 1880s, and Marie Stopes in the 1920s. The development of the female contraceptive pill in the 1960s has now produced a widespread European 'birth dearth'. Having only one brother or sister reduces opportunities for rewarding family relationships (shared genes are no guarantee of compatability), and friendships with peers outside the family increases in importance.

A consequence of this shrinking number of siblings (and, as the generations succeed each other, a declining numbers of aunts, uncles, and cousins) has been to reduce the number of interested adults and young people in a child's world. A pattern of male working lives characterised by long hours spent commuting or working overtime has also hindered fathers from sharing fully in their families, something that was intensified

Jock McFadyen
Two Girls 1985
Manchester City Art Galleries

by the absence of two generations on wartime military service, and a huge loss of male lives. The high take-up of divorce since it became more legally available and socially acceptable has meant that one in four children will be temporarily or permanently deprived of a parent, usually the father.

Technology has also altered the child's experience of home life. It is worth emphasising that keeping house was not always a solitary pursuit. If a home was prosperous, servants helped the lady of the house to run it and to bring up the children. If it was not, there was a great deal of communal co-operation in the form of washing facilities, both for bathing and for laundrywork, bakehouses, and so on. There was a constant circulation of pedestrian traders from door to door: knife-grinders, lamplighters, butchers, bakers, chimney sweeps, and pedlars that must have been quite fascinating to children. Caroline Head's late nineteenth-century diary records the fantasy play of her two year old: 'He constantly plays at being a gardener, or lamplighter, or engine driver, or coal-man, or man with organ and monkey'. All of these interesting people have been replaced over the last hundred years by the new technology of electric domestic appliances, new sources of fuel and power, and the latest in depersonalised shopping exercises, the out-of-town hypermarket.

Childhood is now an experience of consuming food, clothes and entertainments manufactured outside the home and bought with their parents' hard-earned cash, rather than a matter of learning about and contributing to a busy centre of production. The average dual-career family's home is in many ways distinctly dull and lonely for children. Our response has been to supply them with ever more fantastical and hygienic plastic toys, and with playgroups of their peers, special child-orientated environments. It is an ironic reflection of the strength of domestic traditions that they still ape the busy everyday world they have lost in centuries old singing and dancing games: 'Jack and Jill' fetch water from the well, the baker's man goes 'Patacake, patacake', and children nip down the road to buy groceries by pawning the iron ('Pop goes the weasel').

Children are not the only ones to have felt bored and isolated at home. A mother's world also changed once her womb ceased to direct her social existence. Women have always worked or occupied themselves outside the family circle if pregnancies allowed them to. The enormously diminished proportion of their lives spent with babies and small children means that older children are increasingly unlikely to have a mother dominating (and dominated by) the domestic sphere. She may also be distracted and distant – 'emotionally unavailable', is the chilling phrase coined by the newly fashionable family therapists – because of the complicated juggling act she has to perform to keep the competing worlds of work and home satisfied.

Today many children will experience the break-up of their homes; all will be aware because of the experience of friends that such a thing is possible. Images of anxiety are a recurrent theme in modern paintings of children. Smaller families, the strong sense of individual needs created by education, and a less economically stable division of labour between parents have combined to increase the rate of divorce rapidly since changes of legislation in the 1960s. Experiencing the loss of a father or mother is nothing new for children, but in the old days it was more often the inexorable rift created by death that separated child from parent than the unavoidably traumatic announcement that Daddy, or Mummy, would rather live in a different place, perhaps with different people.

But we need to be careful not to romanticise the family of the past. It is hard to know how many more single-parent families have actually been created in absolute terms. It is an accepted historical truism that 'death was the old divorce'; moreover the amateur moles who are burrowing enthusiastically into local parish registers and newspaper files to discover their personal family history are revealing how much unofficial marital separation took place. It is possible that modern statisticians are merely putting on record a long history of ordinary human fallibility.

There are compensations in the present. Poverty is still the major scourge of the single parent family, but compared with 1688, when around 40% of the population was close

to poverty or actually poor, life in material terms is far more comfortable than it ever used to be for the majority of children. We are learning to cope with children's distress at divorce more effectively, to acknowledge the importance of not depriving children of a parent. Nor can we quantify the damage done to children by the more or less perfectly suppressed unhappiness between an incompatible couple. As divorces and separations become commonplace, less personal stigma is being attached to them. One positive aspect of the many families extended by stepbrothers and sisters today is that they resurrect the ancient pattern of learning to parent within the family.

Hopefully, this new frankness between parent and child will lessen the gulf between the artificial 'nursery' world in which we have tried to secure our babies, and indeed much older children, from the realities of everyday life. Benjamin Spock, one of the most acute observers of the contemporary childhood scene, wrote in 1968

> The rearing of children is more and more puzzling for parents in the twentieth century because we've lost a lot of our old-fashioned convictions about what kind of morals and ambitions and characters we want them to have. We've even lost our convictions about the purpose of human existence. Instead, we've come to depend on pyschological concepts. They've been helpful in solving many of the smaller problems, but they are of little use in answering the major questions.[13]

Parents' lack of convictions has made adolescence a tortured time for both parents and children. Children are portrayed as making a better stab at growing up than adults in films such as *Parenthood* or *Look Who's Talking*. The child stars of television series such as *My Two Dads* and *The Wonder Years* are far more streetwise and competent than their parents. It is a commonplace of psychoanalysis that more adults than ever before are failing to graduate from the nursery into the real world – J.M. Barrie's *Peter Pan*, the story of the boy who wouldn't grow up, remains a powerful myth of twentieth-century family life. Spielberg's recent blockbusting sequel to the story, *Hook*, shows men behaving like boys in the boardroom, and a father learning from the Lost Boys how to take responsibility for his children. With role models like these around, it comes as no surprise that children pay more attention to the confident moral platitudes of TV soap operas such as *Neighbours* and *Home and Away* than to their own parents. Perhaps the greatest single difference between childhood in the past and in the present is the strange lack of self-confidence that marks modern parents; the absolute decline of their authority.

1. *The History of Childhood*, Lloyd de Mause, ed., Souvenir Press, 1976.
2. Keith Thomas, 'Children in Early Modern England', in *Children and their Books*, Gillian Avery and Julia Briggs, eds., Oxford, 1989.
3. C. D. Rogers, J.H. Smith, *Local Family History in England*, Manchester, 1991, p.70.

4. Christina Hardyment, *Dream Babies, a History of Childcare Theories from Locke to Spock*, 1983, p.6.
5. Keith Thomas, p.51.
6. The great diurnal of Nicholas Blundell, quoted Pollock, p.237.
7. Quoted Pollock, p.239.
8. Keith Thomas, p.57.
9. 'On Parents and Children', *Essays*, 1597, Dent, 1906, p.21.
10. Alan MacFarlane, *Marriage and Love in England: Modes of Reproduction 1300–1800*, 1986, p.81.
11. J R Gillis, *For Better or for Worse, British Marriages from 1600 to the Present*, 1984, p.22.
12. Rogers and Smith, p.63.
13. Benjamin Spock, *Baby and Child Care*, 1968.

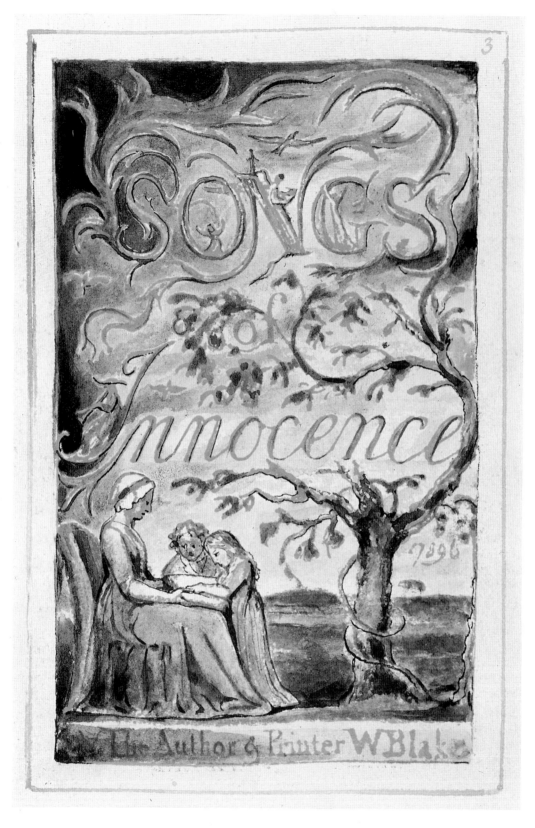

William Blake
Songs of Innocence 1789
Trustees of the British Museum

96 The Family

Catalogue

*Entries
Compiled by
Sara Holdsworth
and Joan Crossley*

Sizes are given in centimetres,
height before width.

The Family

William Mulready 1786–1863

1 *The Lesson* 1859
Oil on panel, 44.5 × 34.3
The Board of Trustees of the Victoria and
Albert Museum

This is an idealised view of the mother as
moral preceptor. The painting was
exhibited with a quotation from Pope's
Moral Essays 'Just as the twig is bent the
Tree's inclined', suggesting that the
maternal influence on the male child was
seen as all important for his future
intellectual and spiritual development.
Pointon tells us that Mulready's concern
with such matters may have owed
something to his relationship with William
Godwin, a liberal educationalist, and with
radical thinkers in the Blake circle. The
natural background may symbolise the
'naturalness' of this form of home
education and its fruitfulness for the mind
and soul of the child. This preoccupation
with the influence of mothers on the
education of their children is an important
theme in nineteenth-century art. The pose
explicitly refers to the Renaissance
representation of the Madonna and Child.[1]
1. Marcia Pointon, *William Mulready 1786–
1863*, Victoria & Albert Museum, 1986, p.129.

Helen Chadwick b.1953

2 *One Flesh* 1985
Colour photocopies from life, 160 × 107
The Board of Trustees of the Victoria and
Albert Museum

Helen Chadwick has chosen to depict the
most traditional of subjects – a mother and
child – in a way that subverts the image's
conventional meaning. Unlike Mulready's
serene *The Lesson* (cat.1), with its
suggestion of Christian piety and
untroubled naturalness, *One Flesh*
confronts us with the physical facts of
childbirth, in the form of a placenta and
umbilical cord.
 In a reworking of a religious painting, the
mother (a friend of the artist) wears red
instead of the Virgin's traditional blue, and
gestures to the child's genitals to indicate
that it is a girl not a boy. Mother and
daughter are 'one flesh' not in its usual
sense of a sexual relationship between man
and woman (Genesis 2:24) but in the
fundamental biological bond of umbilical
cord and breast feeding, and in the fact that
they share the same sex.[1]
 Ego Geometria Sum, an earlier series of
three-dimensional works by Helen
Chadwick, also deals with the relationship
of child to adult. Images of her naked body
cover a pram, piano and vaulting horse to
suggest how her upbringing has moulded
and restricted her.
1. See Gill Saunders, *The Nude: A New
Perspective*, 1989, p.122–3.

Henry Moore 1898–1986

3 *Mother and Child* 1925
Hornton Stone, 56 × 42 × 32
Manchester City Art Galleries

Henry Moore returned to the mother and
child theme continually throughout his
long career. This is an early carving begun
in 1924 when he was teaching at the Royal

College of Art. He had become interested in
ancient Mexican and African sculpture with
its 'simple monumental grandeur and
massive weightiness'[1], and this piece, like
many of Moore's life drawings from this
period, derives not from traditional
Christian iconography but is a reinvention
of what he saw as an archetype of the
'natural' earth mother or fertility goddess.
 In these early pieces Moore tried to give
a feeling of maternal protectiveness without
sentimentality. The rhythmic balance of the
interlocking arms, with the two forms
protecting and encircling each other, gives
the piece a compressed vitality. The
impassive mask-like faces draw on ancient
art and suggest the timelessness and
'naturalness' of the relationship. Later work
by Moore, particularly his reclining
women, make clear his identification of the
female form with the earth, but his
admiration for 'primitive' sculpture, 'static
.. strong and vital, giving one something of
the power and energy of mountains'[2],
suggests that this link is inherent in his

work from the beginning.

1. *Henry Moore: Early Carvings 1920–1940*, exhibition catalogue, Leeds City Art Galleries, 1982, p.26.
2. *Henry Moore: Early Carvings*, p.43.

Eileen Cooper b.1953

4 *The New Baby* 1988
Charcoal on paper, 76.2 × 55.9
Benjamin Rhodes Gallery

Eileen Cooper's charcoal drawings and brilliantly coloured prints and paintings celebrate the mother as the creative principle in the natural world, at one with plants and animals. Unlike Henry Moore's passive monoliths, Cooper's figures are

active and outward-looking, recording with passion the sensations and emotions of motherhood.

In *The New Baby* the mother's wide open anxious eyes contrast with the newborn's serene unconsciousness. An older child at the edge of the picture watches nervously, excluded from the mother and baby relationship. The distortions of scale – the huge eyes and nurturing hands – encourage us to experience the primal bond from the baby's point of view, as well as the mother's.

Sir William Quiller Orchardson 1832–1910

5 *Her Idol* 1868–70
Oil on canvas, 75.2 × 95.9
Manchester City Art Galleries

Orchardson painted scenes of elegant upper middle-class domestic life. His ballroom and unhappy marriage pictures comment on the shallow nature of the social scene. Such works as *Her Idol* show the ideal life for women of this class, focused upon home and child. The title is a mild joke – the child idolises her doll, the mother idolises her daughter. The picture is a comment on the education of daughters. The little girl's intense concentration on the doll suggests that she will in her turn make a wonderful mother. Femininity is stressed by the jewels on the floor, but the mother herself is unadorned, hinting that she has put aside personal vanity and social life. The jewels are now merely the playthings of a child. Likewise, the jewels and the book discarded by the child may represent the false idols of worldliness and learning that she refuses in favour of 'mothering' her doll. An example of 'designer motherhood' – where motherhood and its commercial trappings are glamourised – the picture is a hymn of praise to the absent father whose portrait hangs on the wall behind. The expensive gown and the beautiful room are indicators of his wealth and good taste. Such a well-organised, leisured and expensively serviced domestic life represented an enviable ideal for the Victorian middle classes. Such adoration of an infant by its mother might be criticised as excessive if it implied the displacement of the father in the woman's affections. It would seem in this picture that she is a widow in mourning; she can love the child devotedly while remaining true to her husband's memory. Victorian art registers disapproval and anxiety over the remarriage of widows.

Dame Laura Knight 1877–1970

6 *Dressing the Children* c.1906
Oil on canvas, 102.2 × 139.7
Ferens Art Gallery: Hull City Museums and Art Galleries
(Manchester, Hull and Nottingham showings only)

Painted early in the artist's career at the Yorkshire fishing village of Staithes. Knight joined a community of artists there, where she enjoyed what she felt to be a 'wilder' life. 'The life and the place were what I yearned for – the freedom, the austerity, the savagery and the wildness. I loved it passionately, overwhelmingly, I loved the cold and the northerly storms when no covering would protect you. I loved the strange race of people who lived there.'[1] Knight complained that in the genteel poverty of Nottingham, where she was brought up, she knew nothing of the joys and sorrows of the people around her. Here, in the poor fishermen's cottages, she was able to observe the grinding lives of the poor. Her status as an alien middle-class outsider is emphasised by the use of the term 'strange race'. Like many sympathetic middle-class Victorians, she admired what she saw as the austere beauty of the cottages of the poor. She paid a family by the week to pose for her in their cottage.

The painting also celebrates the virtue of the working-class mother, lovingly dressing the children before a roaring fire, in a scrupulously clean cottage. Knight has left out any tasteless details, such as the newspaper pictures with which working class homes were usually decorated. The cat, which Knight thought was an essential part of the cosy domestic scene, was a 'prop' - a wild cat which kept running away. Despite Knight's desire for authenticity, the

image of the family is generalised, without any focus on the character of the individuals depicted.

1. Caroline Fox, *Dame Laura Knight*, 1988, p.12.

William Hoare c.1707–92

7 *Christopher Anstey with his Daughter, Mary* c.1779
Oil on canvas, 126 × 99.7
National Portrait Gallery

In this portrait of Christopher Anstey (author of the *New Bath Guide*, 1766) William Hoare has aimed for an intimate and informal effect. The author is in his study and is caught half-rising to greet a visitor. The little girl is striving to capture his attention by waving her doll. The artist probably meant to stress what a loving father Anstey was, in having his daughter in his drawing room or study, rather than relegating her to the nursery and the custody of servants, as was customary. Are we to infer some sort of comment on the way in which Anstey is oblivious of his daughter when a newcomer arrives? Or is there some play on his rejection of the fashionable, female world represented by the girl and her grown-up doll? The doll appears to be a mannequin of the type sent from Paris to guide dressmakers towards fashion trends. The depiction of a man with a female child was comparatively unusual, and must have presented a problem for the

artist who would wish to avoid the prevailing sentimentality of mother/daughter or mother/baby images while suggesting an affectionate informality between the father and daughter.

John Henry Henshall 1856–1928
8 *Faither an' Mither an' A'* 1908
Watercolour on paper glued to card, 101.6 × 68.8
Ferens Art Gallery: Hull City Museums and Art Galleries
(Hull, Nottingham and Glasgow showings only)

Henshall specialised in highly dramatic oil and watercolour paintings. This picture shows a working-class grandfather tending his infant grandchild. The title suggests that the parents have died leaving the 'rough' old man to take care of the boy. The painting stands on its head the notion that the male head of the household, as the breadwinner, has to receive the best of everything. His self-abnegation is the ideal celebrated in the picture. Here we see another representation of the Victorian child-angel. Her physical beauty, pale skin and golden hair contrast with the rough hairy masculinity of the grandfather, making her seem like a finer being. We are

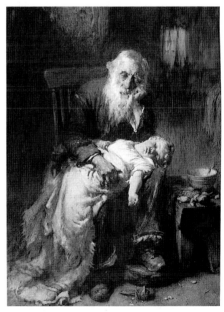

surely asked to reflect upon the ageing process that transforms perfect children into old people. The precarious nature of child-health in the nineteenth century made a painting of a sick child a very poignant and striking image. Luke Fildes' *The Doctor* (1890, Tate Gallery) was another representation of a bedside vigil, this time by a middle-class doctor. If the

painting alludes obliquely to the possibility of losing the child, it points up the economic disaster of losing grown-up children or being orphaned in a society which had only rudimentary poor relief, no pensions or child benefit. Henshall's audience would understand the grimness of the child's future.

Winifred Nicholson 1893–1981
9 *Starry-Eyed* 1927
Oil on sacking, 71.1 × 55.9
Private collection

This affectionate portrait shows the painter Ben Nicholson, Winifred Nicholson's husband, holding Jake, their first son, who was born in 1927. They are standing in front of the leaded range in the kitchen at Bankshead, the farmhouse in Cumberland which the Nicholsons bought in 1923. They had three children. Bankshead was to remain Winifred's main home for the rest of her life, and although Ben Nicholson left her in 1931, he maintained contact with the family.

Winifred Nicholson is best known for her intimate flower paintings in which she experimented with the effects of colour and light. Her portraits, which are also tone and colour compositions, are of people close to her, particularly her children, and all have a calm, domestic quality. In this painting, with its carefully worked oppositions between cool and warm colour, she captures the tenderness of the relationship between father and son without the narrative or anecdotal content of nineteenth-century images of fathers and children.

Cornelius Johnson 1593–1661
10 *The Capel Family* c.1640
Oil on canvas, 160 × 259.1
National Portrait Gallery

This portrait celebrates the good fortune of the Capel family – their fecundity, their beauty and their elegant taste. The father of the family, Arthur, Ist Baron Capel (c.1610–49), was a devoted Royalist, who was to be executed a few weeks after the King in 1649. The eldest son, Arthur, was created Earl of Essex by Charles II on his Restoration. He was a supporter of Charles' eldest illegitimate son, the Duke of Monmouth, whose bid for the throne ended in disaster. The Earl of Essex died in the Tower of London. Although the lives of this family, and many other seventeenth-century families, were devastated and remade by the political upheavals of the period, the portrait was taken when the Capels enjoyed the favour of Charles I, and were able to live a peaceful domestic existence and have the

wealth to enjoy such civilised arts as fashion and gardening. The mother of the children, Elizabeth Morrison, Lady Capel, was sole heiress of the notable estate of Cassiobury Park, Watford. The fashionable garden depicted was at Much Hadham in Hertfordshire. Her surviving son and two of the daughters shown here were to become celebrated horticulturalists. The composition of the picture owes much to Van Dyck's portrait of the children of Charles I with its spread of figures across a horizontal canvas and low viewpoint. The convention of separating girls from boys in family portraits was well-established; here, the sons are displayed before the worldly

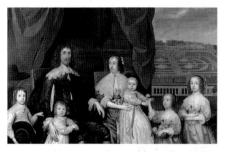

grandeur of the Baroque curtain, while the girls are posed against a backdrop signifying nature and the enclosed world of the garden.

William Powell Frith 1819–1909
11 *Many Happy Returns of the Day* 1856
Oil on canvas, 81.5 × 114.5
Harrogate Museum and Art Gallery Service

This work depicts a Victorian middle-class family gathering to celebrate the birthday of a little girl. Birthdays were of tremendous significance when high infant mortality, even for wealthy children, meant that one in five would die before their fifth year (see essay *The End of Innocence*). The viewer is invited to look at the scene through the eyes of the father, who is gazing out at us, detached from the bustle of the party. With him we see the comfortable, even opulent surroundings that his endeavours have earned. The women of the family are affectionate,

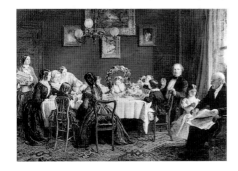

sentimental and ornamental, their elegant dresses and highly-wrought curls a further demonstration of the luxury he has provided. There are also lots of small children, including boys, to carry on the family name and business. It is noteworthy that there is no other male of working age in the picture – we may be meant to conclude that they are at work, with no time for pleasurable gatherings. This is an image of a happy, successful family, modelled according to Victorian ideas of order, with father at the head of the table and at the head of the family. Curiously, the older man, the grandfather, is moved away from the main action into an armchair. This may suggest that the artist wishes to comment upon the continuity and renewal of the family – the young coming up and replacing the mature, who may then rest in old age. This painting reminds us of the importance of ritual and celebration in family life – gathering together and marking occasions of private meaning. It is believed that Frith used himself, his wife and a daughter as models for this picture.

L.S. Lowry 1887–1976
12 *The Family* 1936
Oil on canvas, 44.5 × 36.8
Private Collection, Canada

Lowry once said that he had no happy memories of his childhood: 'I never had a family – all I had round me was a garden fence.'[1] The lack of human warmth which he felt in his own upbringing is apparent in the pictures of family groups that stretch across his career, from the pencil drawings *The Family* (1920) and *Interior Discord* (1922) on which this painting is based, to *Three Figures (Mother and Son)* (1967).

In all these images, which are not of any particular family, parents and children are either locked in hostile confrontation or bleakly isolated from each other. The grim stiffness of the figures in the painting is disrupted, typically for Lowry, by the note of humour in the grinning face of the small girl who peeps out above the table.
1. Quoted in J. Spalding, *Lowry*, 1988, p.17.

Carel Weight b.1908
13 *The Silence* 1965
Oil on board, 89.5 × 120
Royal Academy of Arts

Carel Weight has written that the event that sparked off this picture was Armistice Day: 'it is about the extraordinary annual happening on 11 November at 11 o'clock when everybody stopped the things they were doing and stood in silence in honour of the dead . . .it created a complete silence only broken by a barking dog or a crying

baby.'[1] The three figures – three generations – are remembering the dead, the part of family that no longer exists. They are linked by this silence as they stand in a row in their back garden but also profoundly isolated and separated by it. The invisible barriers between the family members are echoed by the netting cages that enclose the plants.

The picture is set in Carel Weight's own garden in Battersea, South London, 'an unending source of inspiration. I have imagined murders, rapes, surprises and all sorts of wonders there.'[2] Like Stanley Spencer, Carel Weight imposes magical or metaphysical events onto lives of middle-class ordinariness.

This picture was Carel Weight's diploma work, deposited on his election as a Royal Academician in 1966.
1. Private communication from the artist.
2. Mervyn Levy, *Carel Weight*, 1986. p.19.

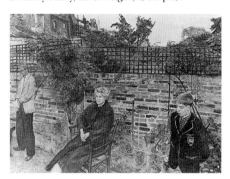

Shanti Panchal b.1951
14 *First Day* 1983
Watercolour on paper, 137 × 91
Bradford Art Galleries and Museums

This is a direct reminiscence of Shanti Panchal's first day at school in Mesar, a village in Northern Gujerat where the artist grew up. He has lived in London since 1978 and paints scenes of the Indian community in Britain as well as his childhood experiences in India. Like many of Panchal's paintings, *First Day* records a solemn moment between individuals as the boy both literally and symbolically sets out on the road from family to society.

The family is shown standing together, closing protectively around the boy. Nevertheless, it is a painting about the psychological move to independence that every child must make and every parent accept. The eyes – unnaturally large like those in Jain miniatures and emphasised by black encircling lines – and the direction of gaze establish the family's sexually differentiated attitudes to separation. The boy's mother and sister look at him and their arms embrace him, whereas his father looks into the distance. The boy also looks

into the distance but in a different direction, suggesting perhaps a separate destiny.

Paula Rego b.1935
15 *The Family* 1988
Acrylic on paper mounted on canvas, 213.4 × 213.4
Saatchi Collection, London

For Paula Rego, born in 1935 in Lisbon, her childhood is both a memory and a living presence which informs all her work. Elements in *The Family* recall directly her own early life. The toy theatre is taken from the one which she played with as a child; the girl holding the man is a portrait of her eight-year-old cousin Manuela; and the clothes that the children wear – the old-fashioned tartan skirt, pinafore and Tyrolean jacket – recall her memories of being dressed up in her best clothes to be shown off to her grandfather's friends. She describes herself as a solitary child who spent hours drawing and playing with toys on the floor of her room. She still kneels on the floor to begin her paintings: 'for me being in this studio . . . is exactly like being in that playroom when I was five.'[1]

All Rego's work deals with the mysterious and forbidden. In *The Family* we seem to be watching a secret family ritual. The clasped hands of the girl by the window and the red 'altar' cloth over the cupboard suggest a religious rite as well as a domestic game. The drama is one of power and sex relations between father and daughters, but it is deliberately unclear whether the inscrutable and prematurely aged-looking children are caring for their father as they dress him, accosting him sexually, or even torturing him. The girls' physical domination of their father is juxtaposed ironically with the other drama in the picture, that of St George slaying the dragon and rescuing the maiden: a conventional image of masculine power.

Also ambiguous are the images of freedom and repression which Paula Rego uses to dramatise the underlying tensions of family life. The constriction of the girls' tight clothes, boots and stockings and their suffocating arms contrast with the light that floods into the room and the wind that blows the curtain.
1. Paula Rego in conversation with John McEwan, *Paula Rego*, exhibition catalogue, Serpentine Gallery, 1988, p.42.

Adrian Wiszniewski b.1958
16 *Robertson Park* 1987
Ink and acrylic on paper, 261 × 182.5
Glasgow Art Galleries and Museums
(Glasgow showing only)

Wiszniewski is a Glasgow artist who produces imaginative, romantic images peopled by dreamy youths – who often seem to be Wiszniewski himself – and adorned with burgeoning vegetation where forms flow and melt into one another.

Robertson Park is based on a memory of a place in Renfrew where Adrian and Diane took their baby son Max for his first outing. Unusually for Wiszniewski the symbolism of the picture is conventional rather than personal. The broken pitcher, gushing water and phallic trees suggest sexual union, and the hourglass establishes the traditional association between children and mortality. The family's union and happiness are expressed not only in their pose – husband and wife provide a mirror image of each other – but in the radiant brightness and vitality of the black lines and light acrylic colours.

Interestingly, the child is not shown as a baby but as a small replica of his father, and his outstretched arm signals a latent determination to cut free of the parental bond.

A Sense of Identity

Paul Van Somer (attrib.) *c.*1577–1622
17 *Child with a Rattle* 1611
Oil on panel, 95.9 × 73.7
Leeds City Art Galleries (Temple Newsam House)

This portrait is now thought to represent Henry Frederick Howard, later 2nd Earl of Arundel. The medallion attached to his girdle has been identified as a Queen Elizabeth I gold sovereign, a typical christening gift of the period. It may be that the presence of the late monarch, who was distantly related to the Norfolk family

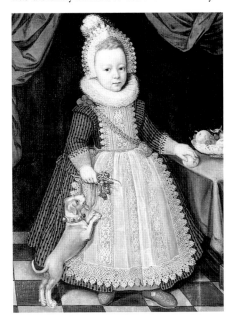

(Howard was the family name, and their crest is on the back of the portrait), was intended to signify their important connections. The boy has not yet been 'breeched', a ceremony marking the arrival of manhood, when boys put off unisex baby dress and assumed the clothes of adult men. This important rite of manhood took place at this time at about the age of five to seven. Although he still has baby status, it is a typical aristocratic portrait, with rich fabrics and valuable trinkets establishing the wealth and power of his family. Despite his youth, he looks calm and coolly assessing, his hand gripping the gold teething ring (an emblem of babyhood) as though it were a field-marshal's baton. The dog, which must have been tiny to be in scale, fawns around the boy, again stressing his importance. This portrait indicates the very short childhoods of seventeenth-century aristocratic children, who were expected to commence a rigorous training and education to assume adult duties at an early age. Van Somer has depicted a boy

who shows every prospect of being a leader.

after Sir Anthony Van Dyck 1599–1641
18 *Five Children of Charles I* 1636–7
Oil on canvas, 89 × 174.6
National Portrait Gallery

This portrait is a contemporary studio copy of the painting in the collection of H.M. The Queen. The child in the centre is the Prince of Wales, later Charles II, who was to endure many years in ignominious exile before being restored to his executed father's throne in 1660. On his left is the young James, Duke of York, later to become King after his brother's death in 1685. He was forced from the throne because of his Roman Catholic and absolute monarchist beliefs only three years later. He was succeeded by his own eldest daughter Mary II and his nephew William III, Prince of Orange. The oldest girl, on the extreme left, is Mary, Princess Royal who was the mother of the future William III. The little girls on the right of the painting, the Princesses Elizabeth and Anne, play together untroubled by their high rank and its duties. The composition of the picture suggests the importance of the heir to the throne, who is given the central position, his commanding hand stilling the great beast into obedience. The position of the Duke of York as second son is indicated by the way he is relegated to the side of the canvas with the eldest sister. Van Dyck has tried to show a future monarch who will have the serenity and wisdom to rule the Kingdom.

Ford Madox Brown 1821–93
19 *The English Boy* 1860
Oil on canvas, 39.6 × 33.3
Manchester City Art Galleries

Fatherly pride in his second son, Oliver, is apparent in this painting by Ford Madox Brown. Oliver was a highly intelligent child, becoming an accomplished painter, novelist and poet by the time of his death at nineteen. In this picture, aged five, Oliver represents an ideal of English boyhood. He is rosy-cheeked and healthy, with big, innocent, yet questioning eyes. He holds a whip and top, denoting hearty outdoor play. His costume is a picturesque and presumably expensive plaid suit with a play smock on top. The brightness of colour and the intensity of Oliver's gaze give this work an emphatic quality missing from many Victorian child portraits.

Augustus John 1878–1961

20 *Robin* 1911
Oil on panel, 41.9 × 33
Private Collection c/o Anthony Mould Ltd.

This is a portrait of Robin John, Augustus John's third child by Ida Nettleship, aged about seven. It was probably painted at Alderney Manor in Dorset where Augustus, Dorelia (who replaced Ida) and the great tribe of John children led an eccentric outdoor life. The boys, who had shoulder-length bobbed hair, either ran around naked to the astonishment of visitors, or wore long, belted smocks made by Dorelia.

John was interested at this time in what

he thought to be the colourful freedom of the gypsy life and travelled around for a short spell in a caravan with his family. This portrait, with its rich colours and the subject's rumpled hair, captures something of the gypsy wildness and picturesqueness that John admired in children. Lawrence Binyon described his figure paintings such as this one as having 'an animal dignity and strangeness, swift of grace, beautifully proud.'[1] Perhaps inevitably, this child of nature rebelled against his upbringing. Robin later wrote 'I hated Bohemianism and yearned for a normal life.'[2]

1. Michael Holroyd, *Augustus John*, 1976, p.433.
2. Holroyd, p.664.

Bernard Meninsky 1891–1950

21 *Boy with a Cat* 1927
Oil on canvas, 123.5 × 55.5
Hove Museum and Art Gallery

The boy in the portrait is the artist's son, David, who was born in 1918. Meninsky's two sons were brought up by relatives and

friends after the break-up of their parents' marriage. Although Meninsky visited the boys (in their different homes), the gulf between father and son is evident in this picture of a lonely, self-contained boy. The child's pose is closed and tucked in, and his expression gives no clue to his thoughts and feelings. His clothes are 'best', with a hat and tie and polished shoes, suggesting he has been dressed up for one of his father's rare visits. His thoughts are detached and far from the artist. Cats are also renowned for their aloofness, and this animal stares out with reproachful and watchful gaze.

Joan Eardley 1921–1963

22 *Philip the Fat Boy* c.1950
Pastel and chalk on paper, 71.1 × 47
City of Edinburgh Art Centre

23 *Little Girl with a Squint* 1962
Oil and collage on canvas, 75 × 49.5
Collection Dumfriesshire Educational Trust, Gracefield Arts Centre

Joan Eardley studied at Glasgow School of Art and travelled in France and Italy on a scholarship before returning to Glasgow in 1949, when she moved to a studio in the East End of the city – 'the living part of Glasgow where the people are … something real.'[1] She soon became accepted in this working-class tenement community and drew and painted many of the children that visited her studio, ate their 'pieces' and played with a box of toys she kept for them. 'Most of them I get on with, but some interest me much more as characters and these are the ones I encourage to come upstairs. They don't take much encouragement to come and be painted. They don't pose. They usually come up and say 'will you paint me?'.[2]

Philip the Fat Boy with its thick black outlines and small areas of colour is an example of Eardley's early graphic style and dates from the period in her first Glasgow studio. In an unsentimental and wrily humorous way she focuses our attention on Philip's buttoned-up jacket which strains at the seams. Although *The Dandy* and *Beano* are at his feet, he is the opposite of the comic book Billy Bunter fat jolly stereotype. His melancholy unfocused expression suggests Eardley's perception of him as a lonely, thoughtful child.

Little Girl with a Squint is a portrait of Pat Samson aged about eight, one of a family of twelve children with whom Joan Eardley became friendly when she worked in a studio in Townhead, a slum district of Glasgow. She said in a BBC radio interview 'this particular family of Samsons move me. They hardly notice me when they come in.

They are full of what they have been doing. Who has gone to jail today. Who has broken into what shop. Who flung a pie in whose face, and so it goes on and on. They are letting out their life.'

Joan Eardley's sympathetic involvement with Pat Samson is clear. Like Philip, she is shown as dreamy and inward, sucking her fingers for comfort. Her squint, like his fatness, is a badge of her withdrawal. However, compared with Victorian paintings of slum children, there is little attempt to provide a narrative or symbolic message about her condition. Eardley was not a campaigning or political artist. In fact, when Pat Samson had her squint corrected

she joked 'Oh hell, she won't be much use to me now!' Pat Samson's clothes, face and the wall behind her are a richly painted celebration of the vitality of the child and her environment: 'I try to think in painterly terms, bits of red, all funny bits of colours. For me they are Glasgow. This sort of richness that I know Glasgow has'.

Like Dubuffet, Eardley was interested in graffiti and what was seen as the primitive energy of child art. The graffiti in this picture are an anagram of Samson; J and A may stand for Jimmy and Andrew, Pat's elder brothers, as if they had left their mark on the wall. The fragment of newspaper, with its seemingly irrelevant message, links Eardley with the young pop artists who were also interested in apparently random urban detritus. It also suggests an exotic adult world far removed from the horizons of a Glasgow slum.

1. Quoted in Fiona Pearson, *Joan Eardley 1921–*

63, National Galleries of Scotland, 1988, p.10.
2. This quotation and the following ones are from William Buchanan, *Joan Eardley*, Edinburgh, 1976, pp.35–6.

Dennis Creffield b.1931
24 *Anxious Baby* 1983
Charcoal on paper, 60 × 42
Private Collection

Dennis Creffield, who studied at the Borough Art School in the 1950s under David Bomberg, made this drawing of his son, Louis, when he was born in 1982. It expresses the vulnerability of a newborn baby, lying prone and exposed. The crying mouth and eyes, drawn-up arms, stiffened legs and sense of unease contrast with our received image of a baby as in a state of mental and physical tranquility. Compare, for example, Eileen Cooper's child who floats blissfully in her mother's arms.

Creffield expresses his own emotional attachment to his son in the rapid and jerky strokes of charcoal, conveying what Peter Fuller called 'an affectionate and creative gaze, a mingling of self and that which is seen.'[1] This feeling is elaborated in a later drawing by Creffield, *Anxious Father, Anxious Baby* (Arts Council Collection).
1. Peter Fuller, *Rocks and Flesh: an Argument for British Drawing*, exhibition catalogue, Norwich School of Art Gallery, 1985, p.13.

Jock McFadyen b.1950
25 *Two Girls* 1985
Pencil on paper, 78.8 × 63.1
Manchester City Art Galleries

Jock McFadyen makes memorable images of sleazy city dwellers. His often grotesque characters are never victims; they seem to put up a game resistance to their grim environment.

He drew these girls in a lorry park in the East End of London where he lives and works. Like those in *Waiting for the Cortina Boys* (1985, Manchester City Art Galleries), a large painting of a similar subject, these girls are engaged in that universal teenage occupation of hanging around waiting for something to happen. Despite the adolescent awkwardness of their pose they have an air of tough nonchalance and look like survivors. The two lorries behind them, with their macho badges and grilles, act as a male presence in the picture; they stand in comically for the boys for whom we guess the girls are waiting.

Peter Blake b.1932
26 *Children Reading Comics* 1954
Oil on hardboard, 37.8 × 48
Tullie House, City Museum and Art Gallery,

Carlisle

This is one of a series of autobiographical paintings that the British pop artist, Peter Blake, started while he was still a student at the Royal College of Art. He was fascinated by the ephemeral products of popular culture – advertising and packaging, toys and comics, film and pop stars – which are such a compelling force in the lives of children and teenagers.

Based on a snapshot of the artist and his sister as children, the work has a very strong element of nostalgia for childhood which was, at the time, not far behind him. The offers and adverts 'Amazing! Easy! Free!', 'Mars are Marvellous', 'A Super Present for every Eagle Reader', return us to a world of 'innocent' consumerism. The snippets of a story 'You are my wounded Prince!', with its wry reference to the girl's eye patch, recall children's love of fantasy and make-believe. The formal pose and solemn expressions show how seriously they take the comic's escapist world.

James Cowie 1886–1956
27 *Falling Leaves* 1934
Oil on canvas, 102 × 86
City of Aberdeen Art Gallery and Museums Collection

James Cowie taught art from 1918 to 1934 at Belshill Academy, a girls' school outside Glasgow. The pupils there, together with his own two daughters, formed his main subject matter during this period. He made detailed studies of each part of a picture before painting, and this may account for the contrived and controlled manner of the finished work. Despite the studies, these are symbolic girls rather than portraits of individuals. One of his pupils recorded how he would use 'maybe half my face and somebody else's ear.'[1]

The strained, formal quality is crucial to his portrayal of what he saw as the conflicts inherent in adolescent girls, poised between childhood and adulthood. The stiff pose, ungainly school uniforms and clumsy hands are at odds with their expressive eyes; one looks meditative, the other gazes heavenwards as if for inspiration. Interestingly, Cowie is said always to have painted the eyes before the rest of the face.

The high, viewless window and boundary wall act as they do in Kate Greenaway's *The Garden Seat* (cat.38) and Kathryn Ensall's *Girls in Line at the Swimming Baths* (cat.28), as an image of restricted girlhood. Outside the window, falling leaves (a direct reference to Millais' *Autumn Leaves* (cat.58)) tell us that this stage of their lives is ending.

Cowie juxtaposes the girls with a plastercast of Michaelangelo's *Dawn*. On one level an art room prop, it is also an image of awakening sensuality. Its relaxed form contrasts with the girls' tension. Their apparent unawareness of its presence heightens our ironic perception of the connection.
1. Cordelia Oliver, *James Cowie*, Edinburgh, 1980, p.16.

Kathryn Ensall b.1956
28 *Girls in Line at the Swimming Baths* 1988
Oil on canvas, 127 × 193
Provident Financial, Bradford
(Hull, Nottingham and Glasgow showings only)

Kathryn Ensall's work is about the social and sexual identity of women. In this

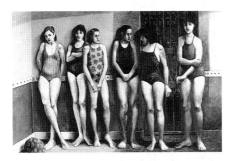

painting, made after spending time drawing in a school in 1988, she explores sympathetically what she calls 'the agonising period' of female adolescence.

The girls stand in defensive and awkward postures backed up against a wall. They are posed as if they are watching the artist or someone in the pool, but the overriding impression is of their awareness of themselves as a spectacle. Kathryn Ensall comments on teenage girls' self-consciousness: 'At puberty women make decisions about their bodies. They learn the advantages of being ever watchful of their own actions, not for the sake of vanity, but in order to achieve an awareness of how their behaviour will be interpreted by others.'

Sonia Boyce b.1962
29 *Big Woman's Talk* 1984
Pastel and ink on paper, 148 × 155
Private Collection

When Sonia Boyce was a student at Stourbridge College of Art and one of the very few black women in the town, she began to draw self-portraits 'to survive' and to 'celebrate the regaining of my political self.' A theme throughout her work is the nature of cultural identity within a racist society: she was born in East London, her

mother is from Barbados, and her father from Guyana.

Big Woman's Talk looks at the cross-generational relationship from the child's point of view. We are on her level and the woman's head is cropped to become just a talking mouth. The child's reverie is ambiguous. It might suggest bored detachment from the older generation – Boyce has said that she regards the family as a microcosm of society, essential but oppressive – or on the other hand, a yearning for adult experience. The exuberant, organic patterns and colours of the Big Woman's dress are a metaphor for the blossoming dreams and fantasies of childhood and express the child's cultural heritage.

Eileen Cooper b.1953
30 *Play Dead* 1991
Oil on canvas, 152 × 168
Benjamin Rhodes Gallery

Like one of Blake's fiery angels, this boy has a burning aura of energy around him. His mother, outside the charmed circle, mourns the end of his childhood, symbolised by the lily that sprouts from his genitals – his blossoming sexuality. The boy is winking at us, only 'playing' dead, but the evening sky and bleak landscape suggest, as they do in many Victorian paintings, intimations of mortality.

This is also a picture about confrontation and rebellion. Eileen Cooper portrays the boy as becoming sexually aware and also as dwarfing his mother – dramatising every parent's sense of being overtaken and left behind by growing children. The relative sizes of the mother and child unnerved the artist's eight-year-old son Sam, who made her promise to 'make the mum bigger next time.'

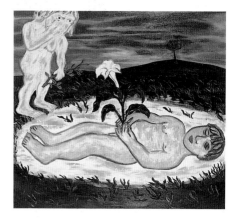

Work and Play

William Hogarth 1697–1764
31 *The Graham Children* 1742
Oil on canvas, 160 × 181
Trustees of the National Gallery (presented by Lord Duveen of Millbank through the NACF, 1934)
(Manchester showing only)

'A conversation piece on the scale of life brought the newly relaxed view of children to an imaginative and inventive artistic height.'[1] Daniel Graham commissioned this group portrait of his children in 1741, soon after he was given his prestigious appointment as Apothecary of Chelsea Hospital by George II. Mary Webster has shown that the baby on the extreme left was Thomas who was born 18 August 1740 and buried 4 February 1741/2. The portrait of the smallest child was therefore posthumous, and this must transform the reading of this picture. It has always been noted that Hogarth has included symbols that hint at the transience of life and the delusions beloved of human nature. The cat is menacing the bird in the cage. It sings in terror. The boy, who has not seen the cat, fondly imagines that he has encouraged the bird to sing with the serinette (bird charmer) which he plays. The French device is decorated with a scene of Orpheus charming the beasts. The clock has a finial of a cupid holding Time's scythe, a reminder that love and youth must give way before time and mortality. The grace, loveliness and charm of these children gain extra poignancy through the fact that the owner of the painting was obviously aware that one of them was already dead.
1. Mary Webster, 'An Eighteenth-century Family: Hogarth's portrait of the Graham Children.', *Apollo*, CXXX, p.171.

Johann Zoffany 1734–1810
32 *The Blunt Children* 1768–1770
Oil on canvas, 76.8 × 123.8
Birmingham Museums and Art Gallery

These two children are believed to be grandsons of Sir Harry Blunt. They are dressed in the long-skirted clothes that all boys wore until they were breeched. Their dress with its lightness and freedom suggests the influence of Rousseau's theories. Images of upper-class children working in gardens became popular in the mid- to late eighteenth century, also prompted by Rousseau's writings on the healthy upbringing of the young. The setting is a fashionable landscape garden with a park behind. The odd little figures are dwarfed by a long-established tree (symbolising longevity and continuity) and

the eventual mortality of all living things is suggested by the stump of a dead tree beside them.

Joseph Wright (of Derby) 1734–97
33 *The Wood Children* 1789
Oil on canvas, 167.7 × 134.7
Derby Museum and Art Gallery

This is a glamorous portrait of three children playing. Although the painter desired to create a relaxed, unstudied portrait by giving the children the 'props' of a game of cricket, it is very carefully composed with its triangular arrangement of figures. The setting is a wood,

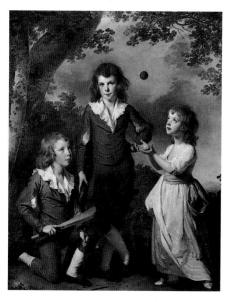

undoubtedly in the Park of their country house.

Eighteenth-century beliefs about the importance of dressing children in freedom-giving clothes may be seen here. The stiff fabric and unwashable embroideries of the Van Somer portrait have been replaced by breeches, tunics and open-collared shirts for the boys and a cotton dress, tucked up to allow movement, for the girl. The portrait emphasises the physical beauty of the sitters, with their big eyes and red mouths. The artist has given their flowing hair a marvellous glossy texture, denoting health and good upbringing.

John Quinton Pringle 1864–1925
34 *Children at Play* 1905
Oil on canvas, 76.2 × 63.6
Hunterian Art Gallery, University of Glasgow

J.Q. Pringle painted mainly very small-scale townscapes and landscapes, the latter often peopled with pale Whistlerian girls. He also

painted portraits of the children of friends, including those of Fra Newbery, head of Glasgow School of Art, in miniature on ivory.

In *Children at Play* Pringle depicts two rather prim-looking girls dressed in the 'artistic' smocks and hats of the Edwardian era. They are painted as fragile and decorative elements in a shimmering landscape. The identification between the girls and nature is made clear by their (slightly incongruous) bare feet and pale thin legs which echo the spindly tree trunks. The setting sun gives a wistful, elegiac note to the scene, inviting comparisons with Millais' *Autumn Leaves* (cat.58).

circle of Henry Charles Bryant *fl.*1860–80
35 *The Lowther Arcade* c.1870
Oil on canvas, 58.5 × 81.2
Coutts & Co.

The setting of this picture was the shopping arcade which ran from the Strand to Adelaide Street, a site now occupied by Coutts Bank. The Arcade was renowned for its toy shops. The work celebrates and comments on children as consumers. In the nineteenth century, the potential of children as a market was fully realised for the first time. Middle and upper-class children occupied nursery suites separated from the rest of the house, and these were decorated in specially designed papers, fabrics and pictures. Books, clothes and toys for children proliferated as middle-class affluence grew. Here, happy children are choosing exciting toys watched by less fortunate children who covet their possessions. The artist has nicely observed the pleasure adults receive from buying for their children.

Mark Symons 1886–1935
36 *The Day after Christmas* 1931
Oil on canvas, 91 × 68
Bury Art Gallery and Museum

This depiction of the lassitude that follows the annual bourgeois orgy of present-giving has a curiously unfestive, almost sinister, atmosphere. Despite the exuberance of the Christmas decorations, the mass of choking detail and pattern makes the picture claustrophobic. The children have an imprisoned, doll-like quality, underlined by the dolls they are playing with. The sense of threat is intensified by the girl sitting on the floor who waves a stick and has a hand round the neck of her doll; a Christmas streamer is wound, manacle-like, around her neck and ankle. The violence and abandonment of the small children playing

on the floor contrasts with the control of the two elder girls who are carefully building a complex structure on the table.

Mark Symons painted many pictures of his own children, of which this is almost certainly one. The interior may be taken from his home in Caversham where he lived until 1933. As well as family studies he painted religious pictures (he was a devout Catholic) and fairy scenes.

Frederick Daniel Hardy 1826–1911
37 *Early Sorrow* 1861
Oil on canvas, 21.5 × 34.7
Towneley Hall Art Gallery and Museums, Burnley Borough Council

Hardy was a member of the Cranbrook Colony, established in the picturesque village of Cranbrook in Kent by Thomas Webster. The group, a loose affiliation of friends and families, painted small scenes of domestic life. Hardy specialised in painting children from the working and middle classes. He was interested in the way children act out and interpret adult habits and rituals in their play. Here, the children stage an elaborate funeral for a bird, complete with mourners, a grave digger and a bier. Obviously they are imitating a funeral that they have witnessed, turning real sadness into play. Perhaps Hardy was commenting on the intensity with which children feel their lesser griefs. The two adults in the room suspend their work, bemused by the seriousness and fidelity of the game. Their faces do not register amusement, perhaps suggesting that they feel the poignancy of children coming close to death even in play. In Hardy's paintings there is a fascinating gulf

between what we the audience understand as adults, and what the children in their innocence perceive.

Kate Greenaway 1846–1901
38 *The Garden Seat* c.1890s
Watercolour on board, 20.4 × 25.5
Royal Albert Memorial Museum, Exeter

Primarily known as an illustrator of books for children, Greenaway trained as a painter and exhibited a number of watercolour scenes. Working in the last quarter of the nineteenth century, her work evoked the costumes and manners of the Regency period, which was believed to be more 'aesthetic' and innocent than her own. This painting shows a preoccupation with clothes which was characteristic of Victorian painters. The little girl is a beautiful, doll-like child, forced to perch rigidly on the seat, so as not to get her feet damp or to spoil her costume. Girls were considered to be delicate in health, so that damp feet or a chill might prove fatal. The boy, by contrast, has been playing a more energetic game with a hoop, and has paused as if to have his photograph taken. It is not clear whether the elegant young lady is their sister or mother. She is wholly absorbed in reading her novel – usually a sign of levity and endangered morals in Victorian art.

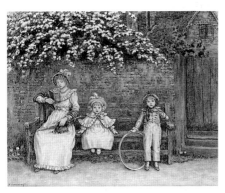

William Hogarth 1697–1764
39 *The First Stage of Cruelty* from *The Four Stages of Cruelty* 1751
Engraving, 39.5 × 33.7
Trustees of the British Museum

This is the first of the engravings depicting *The Four Stages of Cruelty*. Hogarth later wrote that he had executed them 'in hopes of preventing ... that cruel treatment of poor Animals which makes the streets of London more disagreeable to the human mind than anything whatever'. The majority of evil-doers here are adolescents or children – Hogarth shows them torturing animals for experimentation or sheer amusement. The two main

protagonists are the 'Youth of gentler heart' who bargains for the release of the poor dog, and the 'Tom Nero' character who is unmoved by bribery or pity. His fate is suggested by the gallows chalked on the wall beside him. Hogarth here presents an unidealised view of boyhood, as cruel and unfeeling. The brutalisation of animals is later practised upon humans, and will inevitably rebound on the perpetrators of cruelty themselves.

George Fullard 1923–1973
40 *Children Playing Soldiers* *c.*1950s
Ink on paper, 55.9 × 36.8
Sheffield City Art Galleries

41 *Children and Pushchair* 1956
Ink and wash on paper, 32.5 × 28.5
Private Collection

George Fullard is best known as a sculptor of playful wooden assemblages influenced by Picasso and Paolozzi, many of which are of a mother and child. He also made many lively and original drawings of this subject.

Fullard was especially interested in children, their games and imagination, and compared their make-believe to the creative act of the artist: 'just as the child, without effort, slips through imagination out of life to make a man out of a pepperpot or the heaving deck of a shipwreck out of a placid pavement, so the artist works towards the miracle of making visible that which apparently could not exist.'[1]

In *Children Playing Soldiers* three boys act out aggressive adult male roles in play. Many of Fullard's best drawings and sculptures, such as *Death or Glory* (1963–4, Tate Gallery), take a satiric opposition to war as their stand, perhaps influenced by his own wartime experiences; he was badly wounded at the Battle of Cassino. He was not, however, a politically committed artist; his wife remembers him saying that 'Picasso has done more for children than most politicians.'

In *Children and Pushchair* Fullard captures the unthinkingly affectionate relationship between the two children and, in the boy's inventive way of pushing his sister, children's desire to turn mundane tasks into play.

1. Quotations are from *George Fullard Drawings*, Exhibition catalogue, Arts Council, 1982.

John Faed 1820–1902
42 *Boyhood* 1849
Oil on canvas, 101.5 × 85.7
The FORBES Magazine Collection, New York

Faed specialised in amusing and 'telling'

scenes of childhood. In this painting he is depicting the masculine tendency towards aggression. He also introduces a class element: the well-dressed lad, sobbing with fear, is being rescued from the pugilistic skills of a bare-footed boy. The poorer boy, though violent, is quite favourably depicted as handsome and upstanding. Perhaps he is meant to be a fine example of British boyhood. The rivals are being separated by a very sour-looking old gentleman, who may be their schoolmaster. In Victorian art, images of boyish aggression were frequently treated as evidence of the martial spirit needed in business and Empire.

Christopher Stevens b.1961
43 *Giant* 1988
Oil on linen, 183 × 114.5
Collection of the Artist

Much of Christopher Stevens' work is about the nebulous borders between childhood and adulthood. In *Giant* the boys literally try on an adult role for size. Their play is given a frightening undercurrent by the looming 'bogey-man' silhouette of the coat, which recalls Goya's images of fantastic witches and demons in *Los Caprichos*.

Stevens intends us to read the work not only as an image of children's powerful imagination but as a metaphor for adult consciousness which cannot escape our childish selves: 'we all carry inside us the children we once were.'

Thomas Webster 1800–86
44 *The Boy with Many Friends* 1841
Oil on panel, 62.2 × 90.5
Bury Art Gallery and Museum

Webster was the leading figure in a group of artists known as the Cranbrook Colony,

which specialised in painting children, often in nostalgic rural cottage interiors (see also cat.37). The prosperity enjoyed by the group indicates that they found a ready market for their work and is another instance of the Victorians' passionate interest in all aspects of childhood. The Cranbrook artists were fascinated by children's likeness to and difference from adults. Did these differences stem from education, nurture or innate instincts? As might be expected, no very deep conclusions were reached, but Webster, as here, frequently produced sympathetic and insightful studies of groups of children.

The Boy with Many Friends is set in a boarding school. A small boy, probably new to the school, judging by his distinctly rustic clothing, is bewildered to find himself the focus of many 'friends' all eager to beg, barter and buy the contents of his food hamper. This is not an idealistic view of young males: the boys are shown as aggressive, sly and greedy. In the background there are the more sensitive and worthy members of the school; a little schoolboy glances up disapprovingly from his book, and a sad, homesick boy sinks his head in grief, perhaps shocked by the crude behaviour of his companions. This very masculine world is full of conflict and competition.

William Mulready 1786–1863
45 *Train up a Child in the Way He Should Go and when He Is Old He Will not Depart from It* 1841
Oil on panel, 64 × 77.5
The FORBES Magazine Collection, New York

This strange work depicts an angelic child being encouraged to give a coin to three frightening beggars. It is a complex painting which invites the viewer to note the contrasts of class, race and physical appearance between the figures. It deals with the moral training of children, and the need for charity by presenting a contemporary social problem. The figures on the extreme right are 'Lascars', seamen recruited by the East India Company who had become stranded in a cold and unfriendly climate, presumably awaiting a ship going home. Their plight was the subject of a campaign in the press in 1841 when Mulready began this work. The rural setting is far from the scene of the actual crisis, the London docklands, and this allies the work to a tradition of rural scenes in which gentlefolk tend the needs of the grateful poor. The painting eventually acquired this title which comes from the Book of Proverbs 22:6, and relates to the need for children to absorb the correct

moral training in their youth so that they will be set on the right path for life. The child's place in the world is made clear from his upright (though hesitant) stance and his act of charity.

1. Marcia Pointon, *Mulready*, 1986, pp.125–7.

Artist unknown
46 *Blue Coat Schoolboy* and *Schoolgirl*, late
47 18th-early 19th century
Carved wood, 75 × 27.1 × 14
Maidstone Museum and Art Gallery

Until 1847 these two figures stood in All Saints' Church, Maidstone, in a niche on either side of the west window. At that time they were painted blue and white in imitation of the uniform of the Blue Coat Charity Schools (founded 1711). It is thought that they were placed above a collecting box, to which they pointed, urging the congregation to donate to their cause. The figures remind us that in the eighteenth century education for the poorer classes was left to charitable initiatives. The carving of the figures, although crude, is suggestive of the qualities they advertise about the children receiving charitable education. They are dressed neatly but suitably for their humble station. The boy has doffed his hat respectfully. The girl, wearing a modest cap, is clutching a book, almost certainly the Bible or a book of sermons. These qualities of submission, religion and discipline were precisely what the middle classes expected to see as a return for their generosity.

James Lobley 1828–88
48 *Ragged School Studies* 1859–1880
Bradford Art Galleries and Museums

a. Study of a Small Boy from the Back, Standing
Pencil and watercolour on paper
13.5 × 9

b. Study of a Small Boy, Seated, his face Hidden by his Left Arm
Pencil and watercolour on paper
13.5 × 9.5

c. Study of a Small Boy Standing, with Clasped Hands
Pencil and Watercolour on paper
14 × 9

d. Study of Two Small Boys, Standing
Pencil and watercolour on paper
14 × 18.5

e. Study of a Small Boy Seated, Holding a Book
Pencil and watercolour on paper

14 × 11.5

f. Study of a Small Boy Seated in Profile, His Face Hidden
Pencil and watercolour on paper
12.5 × 9

Lobley, a Bradford artist, made these sketches at the local Ragged School. This charitable institution was set up by leading Bradford Non-Conformists to 'reclaim and instruct those children who, through neglect, the extreme poverty, or the vice of their parents, or those who have charge of them, are beggars or vagrants or in imminent danger of becoming such.'[1] It is

not known whether Lobley made these studies in preparation for a painting, or for one of his patrons who was on the Ragged School Committee. He may simply have done them for pleasure. Lobley did a number of paintings dealing with the sufferings of the poor and it is clear that he felt great compassion for them, particularly for their children. The poor circumstances of the children at the Ragged School are revealed by these drawings. Their clothes are very worn and ragged, they are often barefoot or wearing ill-fitting handed-down boots. The health and happiness of these small models is not easy to discern, although one small boy hides his face as though in sorrow.

1. *James Lobley 1828–1888*, Bradford Art Galleries and Museums, 1983, p.19.

Thomas Gainsborough 1727–1788
49 *A Peasant Girl Gathering Faggots in a Wood* 1782
Oil on canvas, 169 × 123

Manchester City Art Galleries, purchased with the aid of V&A and NACF grants.

This is one of Thomas Gainsborough's so-called 'fancy' pictures of poor children set in wild landscapes which he painted at the end of his life, as a relief, he claimed, from society portraits. Uvedale Price records that on their rides together, 'When we came to cottage or village scenes of groups of children or to any subject of that kind which struck his fancy, I have often remarked in his countenance an expression of peculiar gentleness and complacency'.[1]

The peasant girl presents a very idealistic version of what life was like for poor children of the period. She has the melancholy beauty and a simplified version of the dress of one of Gainsborough's aristocratic subjects. The face draws our attention by its clarity of detail compared with the loosely painted figure and landscape. The highlights in the eyes suggest a trembling tear. The atmosphere is what was described at the time as 'that pathetic simplicity which is the most powerful appeal to the feelings.'[2] At the same time, our response is complicated by the girl's naked shoulders and averted eyes, which offer her as a sexual object for our scrutiny.

Gainsborough charged his highest prices for these works which were much in demand. Their show of rustic sensibility chimed with contemporary opinion, which liked to imagine the rural poor as humble and grateful objects of the benevolence of the rich. One commentator has pointed out that the girl's appeal to the eighteenth-century viewer's sense of protectiveness depends on her being shown at work, and thus as one of the deserving rather than the idle poor.

1. Quoted in John Hayes, *Thomas Gainsborough*, Tate Gallery, 1980, p.38.
2. Hayes, p.38.

Sir George Clausen 1852–1944
50 *The Stone Pickers* 1887
Oil on canvas, 106.5 × 79
Laing Art Gallery, Tyne and Wear Museums Service

Clausen, influenced by the French realist Bastien-Lepage, produced a series of paintings of field workers which were intended to depict modern peasants with as little artifice or comment as possible. He sketched and painted out of doors as well as taking photographs of his subjects which are among the earliest studies of labourers at work.

Picking stones from the surface of fields was a task undertaken before ploughing or haymaking by women and children

employed as casual labour. Clausen's girl appears to be in her mid to late teens: she was modelled by an actual working girl, the family housemaid Mary Baldwin. Her downcast eyes indicate at once her maidenly modesty and her consciousness of her lot.

The girl's large hands and heavy boots declare her life of manual labour. The high horizon, low viewpoint, and the way that the figure is placed centrally at the front of the picture plane also serve to confront the viewer powerfully with her presence. Despite Clausen's avowed intention to avoid sentiment, her sad spirituality, like Gainsborough's *Peasant Girl*, makes her an object of our pity. A bent old woman in the background adds a narrative element: she is the image of what the girl will become.

The End of Innocence

William Blake 1757–1827
Songs of Innocence and of Experience
51 Facsimile edition of 16 plates from *Songs of Innocence and of Experience*, Manchester Etching Workshop, 1983.
52 Facsimile edition of *Songs of Innocence and of Experience* (1826 Library of Congress copy). Trianon Press, 1955.
Manchester Central Library

The poet/painter William Blake is an important figure in the consideration of the culture of childhood. His apparently simple poems for and about children in *Songs of Innocence* and *Songs of Experience*, 1789 & 1794, sum up many strands of thought on the subject in the late eighteenth and early nineteenth centuries. A complex debate exists on the precise meanings of the *Songs* and the poet's intentions in writing them. Blake had a very personal philosophy and theology and used religious symbolism in new and original ways in his art. On a simple level, his work reflected a fairly new belief that children were important. More than that, children in their innocence were closer to the sources of spiritual truth than adults. He believed that repressive social and educational systems corrupted adults making them unable to perceive what is clear to children. The poems show an empathy for children oppressed by adult cruelty, by exploitation at work or by life-denying religion and education.

William Blake 1757–1827
53 *The Good and Evil Angels Struggling for Possession of a Child* c.1793–4
Watercolour, pen and ink on paper, 29.2 × 44
The Trustees of the Cecil Higgins Art

Gallery, Bedford, England
(Manchester showing only)

This subject appears several times in Blake's work, as part of his consideration of the nature of man. The good angel, balancing on clouds, holds a young child out of the reach of the evil angel who is shackled in his fight for the soul by being tied at the ankle. In an earlier work Blake used the same composition and stated that it illustrated the following points; '1. Man has no Body distinct from his Soul ...2. Energy is the only life and is from the Body and Reason is the bound or outward circumference of Energy. 3. Energy is Eternal Delight.' (*Marriage of Heaven and Hell*, c.1790–3, pl.4.) *The Good and Evil Angels* illustrates the idea of the dual aspect of human nature – with man perpetually torn between the desire to do good and the temptation to do evil. It also carries complex iconographical meanings as part of Blake's philosophical system. On one level Blake is using good and evil in traditional ways, but he also held highly unorthodox views about their meaning. They were necessary and dynamic contraries – 'Good is the passive that obeys Reason. Evil is the active springing from Energy.' In other words, the apparently 'evil' energy is a powerful and vital force in human experience, linked to the imaginative and creative powers of the artist.

Allan Ramsay 1713–84
54 *Sketch of a Dead Child* c.1743
Oil on canvas, 32 × 27.3
National Galleries of Scotland

The child was the artist's own son, Allan, who died c.1743. Ramsay, writing to the Countess of Bute, recounted his grief at the loss of this eldest son and dearest child. As he was sitting with him, he was suddenly moved to take the dead child's likeness and recorded that while he painted the grief left him, but returned as soon as he stopped. Ramsay's account suggests an important reason for making images of dead babies – as a kind of therapy for alleviating the sense of loss. Parents sometimes commissioned artists to paint the death-beds of their children, and the paintings might be used for more finished portraits or funerary monuments.

Sir Joshua Reynolds 1723–92
55 *A Child's Portrait in Different Views: 'Angels' Heads'* 1786–7
Oil on canvas, 74.9 × 62.9
Tate Gallery, presented by Lady William Gordon, 1841

These 'angels' are all portraits of Frances Isabella Gordon (1782–1831), who was approximately four years old when the work was executed. Reynolds was known for his sensitive portraits of beautiful children – he painted his great-niece in a white frock as *The Age of Innocence* (c.1788, Plymouth City Museum and Art Gallery). It is evident that Reynolds was interested in contemporary ideas about the moral perfection of young children. The work is an appreciation of child beauty. The babyish contours of the face, the large, wide-apart eyes and the soft hair are all depicted in a pure asexual way. The child is shown without any coy references to her future beauty as an adult or any 'props' and costumes which would assert her family's social status.

George Frampton 1860–1928
56 *Peter Pan* 1913
Bronze and wood, 61 × 26.6 × 35.5
The Hon. Mrs Gascoigne, Stanton Harcourt

This bronze is a small-scale version of the figure in Kensington Gardens, London, erected on the spot visited by this character in J.M. Barrie's story (1902). The model was presented to Lewis Harcourt, 1st Viscount, then Minister of Works, who helped secure the site in the Gardens. Peter Pan reappeared in Barrie's famous play (1904) and has an extended life in Disney and other films. The appeal of the boy who never grew up is a potent one: he declares in Act I of the play 'I want always to be a little boy and have fun'. The perpetual boy escapes family ties, marriage, fatherhood, work and all the trammels of adult life. Peter's life is a constant adventure, with himself as gang leader. It is arguable that the eternal boy aspect of the play appeals more to grown men than to their children. The figure is light, suggesting the imminence of flight, but there is a faint air of melancholy in his absorption.

Paula Rego b.1935
57 *Wendy and Captain Hook* 1992
Colour etching, 62 × 50
Marlborough Graphics Ltd.

Paula Rego's Peter Pan etchings follow her series of nursery rhyme prints which are startlingly subversive interpretations of familiar jingles.

Her re-working of Barrie's story is similarly unsettling. In this print Wendy has a knowing and slightly smug expression. As the 'little mother' of the Peter Pan tale she is shown taking charge of the ferocious-looking Captain Hook; a child-adult role-inversion which is an important theme in Rego's work.

Sir John Everett Millais 1829–96

58 *Autumn Leaves* 1855–6
Oil on canvas, 104.1 × 73.6
Manchester City Art Galleries
(Manchester showing only)

A poetic painting of four young girls
gathering and burning autumn leaves. 'The
season, the dead leaves, the smoke and the
sunset are all images of transience....It is a
setting redolent of decay and death that
makes us conscious that the girls in the
foreground, for all their youth and beauty,
must inevitably go through the same
processes.'[1] The picture of girls
approaching puberty or marriageable age
has overtones of sexuality, implying the
passing of the barrier between innocence
and knowledge. The apple in the small girl's
hand is symbolic of the season but also
reminds us of Eve's Fall into Original Sin
that made mankind subject to mortality.
1. Tate Gallery, *The Pre-Raphaelites*, 1984, p.139.

Terry Atkinson b.1939

59 *The Stone Touchers I*
Ruby and Amber in the Gardens of their
Old Empire History Dressed Men 1985
Acrylic on board, 121 × 90
Gimpel Fils

Terry Atkinson sees painting as part of a
wider intellectual activity which includes
writing and teaching. For many years he
was part of the *Art and Language*
conceptual art group, and he still deals with
political and ideological issues using texts
in a deliberately didactic way to explain his
images.

Like Howson, Atkinson uses children to
explore the destructive urges in our society,
but his ironic intellectualism and brightly
coloured 'happy family' snapshot format are
very different from Howson's dark
melodrama.

In *The Stone Touchers I* Atkinson's
daughters pose in front of World War I
graves, a juxtaposition which links the
personal and subjective with wider political
and historical issues. He calls the girls
'stone touchers' partly to place them in an
historical continuum which stretches from
the death of a young soldier in 1916 to their
nuclear-age future and also perhaps to
suggest a superstitious and futile attempt to
ward off this fate.

Atkinson's text or 'Map Key' which
accompanies the picture underlines his
theme of the abuse of male power. The
inscription on the tombstone, 'known unto
God a soldier of the Great War,' ironically
points out the connection between the
paternalistic Christian God traditionally
invoked in war and the God-like power of
modern nuclear weapons. Ruby and Amber
are 'known unto Cruise' and 'SS20.' As
Atkinson has written: 'Imagine the nuclear
explosion as sacred in its awesomeness. A
judgement from some apocalyptic
fundamentalist Bible-belt God.'[1]
1. 'Tales from the Bunker', in *Art from the
Bunker: Work 1983–1985*, exhibition catalogue,
Gimpel Fils, 1985.

Bill Woodrow b.1948

60 *Tricycle and Tank* 1981
Tricycle and enamel paint, 40 × 60 × 40
Private Collection, London

Bill Woodrow's sculptures never include
human figures but often imply their
presence. His work has an anthropological
quality in which material artefacts serve as
evidence for underlying relationships in
society.[1]

Woodrow made this sculpture after
finding the battered tricycle in a street in
Brixton near where he lives. He decided to
juxtapose it with a tank, which grows out
of the seat. A tank is an instrument of
warfare as far removed from a child's toy as
possible, but one that has at the same time
been turned by our culture into a child's
plaything: 'toys for the boys.'

Tricycle and Tank, like many of
Woodrow's pieces, is anti-militaristic. In its
delight in the imaginative recuperation of
what has been discarded it is also quietly
anti-consumerist.
1. See Lynne Cooke, 'The Elevation of the Host',
Bill Woodrow: Sculpture 1980–86, Fruitmarket
Gallery, Edinburgh, 1986, p.1.

Carel Weight b.1908

61 *Frightened Children* 1983
Oil on canvas, 34.3 × 36.2
Alan Yentob

'I aim to create a world superficially close
to the visual one but a world of greater
tension and drama – the products of
memory, mood and imagination rise upon a
foundation of fact. My art is concerned with
such things as love, hate, fear and
loneliness, emphasised by the setting in
which the drama is played.'

Frightened Children is one of several
works depicting figures running from an
attacker. All have a nightmare quality, a
Munch-like note of rising panic. Here the
attacker is more frightening for being
unseen, and the wall with its enormous
shadow blocks the children's path. It is a
picture of deep psychological drama and
menace, relating perhaps to memories of
early childhood. Carel Weight describes
himself as having been a lonely boy living
in his imagination with terrors; he
remembers his grandfather as 'an emblem
of sheer fear.'
1. Quoted in Mervyn Levy, *Carel Weight*, 1986,
p.62.
2. Levy, p.24.

Peter Howson b.1958

62 *Blind Leading the Blind I* 1991
Oil on canvas, 244 × 183
Angela Flowers Gallery

Peter Howson, who lives and works in
Glasgow, is known for his dramatic
expressionist figures: soldiers, boxers and
Glaswegian 'hard men' and dossers. Painted
on a grand scale, but hardly heroic, these
men are galvanised by despair, aggression
or eye-popping rage.

In his new series *Blind Leading the
Blind* Howson is inspired by Brueghel's
painting of the same title in which a string
of blind men follow each other into a
watery ditch. Howson has created a
contemporary version of Brueghel's moral

fable in which men, women and children act out furious and futile dramas against desolate landscapes.

In this picture, a mother (whose giant stride is perhaps an echo of *Dulle Grillet*) escapes with her children from a grim monolithic city and rushes in panic into the sea towards an apocalyptic light. Behind her a chapel (an image also taken from Brueghel) – a symbol of religious authority – stands abandoned and transformed into a

sewage outlet onto the beach.

The image of an adult blindly and ignorantly leading children into danger is a disturbing one; it disrupts our preconception of the mother as nurturer and protector. Innocence, too, is a quality that does not exist here. The children have been marked by the world: the little boy shows the manic intensity of many of Howson's adult men and the little girl's expression is prematurely grim.

Sir Peter Lely 1618–80
63 *Lady Charlotte Fitzroy* c.1672
Oil on canvas, 127 × 101.5
York City Art Gallery

The girl in this painting was one of the daughters of Charles II from his long relationship with Barbara Castlemaine, Duchess of Cleveland. Painted some years after her parents parted, the child had recently been accorded near Royal status by her affectionate father. Although she was only eight, the portrait was executed to celebrate her bethrothal in 1672. She was married to Sir Edward Henry Lee in 1677, and the groom was made Baron of Spelsbury, Viscount Quarendon and Earl of Lichfield. She bore thirteen sons and five

daughters. The work can be seen as part of her parents' determination to provide for her future. The kneeling servant emphasises the child's important status. He also serves as a reminder of Charles' success in negotiating a British foothold in India through his marriage treaty with the Portuguese princess, Catherine of Braganza. Presumably the young Indian, who looks hardly more than a child himself, would have come to Britain on a trading vessel. Black servants were highly fashionable in this era and signify luxury and the exotic. The representation of the little girl is highly sexualised, with the erotically bared shoulder and sultry gaze, and is very similar to Lely's portraits of her mother and other Court beauties.

Frederick Smallfield 1829–1915
64 *Early Lovers* c.1859
Oil on canvas, 76.4 × 46.1
Manchester City Art Galleries

This tryst between two young lovers epitomises Victorian ideas about 'innocent' love between children and teenagers. A contemporary praised it as a 'thoughtful moment of boy-love' which is 'too fledgeling and restless to be gay'. Dickens celebrated a similar moment in *Sketches by Boz*:

> They have dreamt of each other in their quiet dream, these children, and their little hearts have been nearly broken when the absent one has been dispraised in jest. When will there come in afterlife passion so earnest, generous and true as theirs; what, even in its gentlest realities, can have the grace and charm that hover around such fairy lovers?

The chastity of Smallfield's lovers is stressed by the stile that divides them (a common feature in nineteenth-century courtship paintings) and by the soulfulness of their expressions.

The title is taken from a poem of 1827 by Thomas Hood, from which Smallfield borrows the June twilight setting and the theme of a poignant moment of parting:

> It was not in the Winter
> Our loving lot was cast
> It was the Time of Roses,
> We pluck'd them as we pass'd.

The plucked flower, which the poem elaborates as a rosebud that is pulled apart 'to the dainty core', is traditionally used to suggest loss of virginity. Despite the spray of roses at the girl's feet, this sexual dimension is deliberately absent from the painting.

Gerald Brockhurst 1890–1988
65 *Adolescence* 1932
Etching, 38.5 × 27.5
Trustees of the British Museum

Brockhurst painted and etched many mannered but haunting images of beautiful women in the 1920s and 30s, but his best known work is *Adolescence*, a nude portrait of his mistress Kathleen Woodward, renamed Dorette. He met her when she was sixteen and working as a model at the Royal Academy Schools and he was thirty-eight. The contemporary press reported the sensational divorce case from his first wife and the relationship with Dorette with such headlines as 'Moulded the Mind of a Girl'.[1] In fact, Dorette was twenty – hardly adolescent – when this etching was made, but it is a powerful image of awakening sexuality.

Its voyeuristic quality depends partly on the setting, which provides the frisson of a glimpse into the private world of a girl's bedroom with its scattered underwear and childish ornaments like the little black dog hanging from the mirror – but also on the naked girl's apparent unawareness of any spectator as she contemplates her own

sexuality. As John Berger has written about such 'vanitas' paintings: 'The real function of the mirror . . . was to make the woman connive in treating herself as, first and foremost, a sight.'[2]

1. Quoted in *A Dream of Fair Women: An Exhibition of the Work of G.L. Brockhurst*, Exhibition catalogue, Sheffield, Birmingham, London, 1987, p.18.
2. *Ways of Seeing*, 1972, p.51.

Peter Blake b.1932

66 *Daimler* 1980
Oil on canvas, 64.8 × 54.6
The Jaguar Daimler Heritage Trust

After moving from London to the country in 1969, Blake formed the Brotherhood of Ruralists, a small group of artists who took childhood and fairy tales in a rural setting as their subject. This change in Blake's interests was partly due to disillusionment with city life and culture and partly to a growing enthusiasm for Victorian paintings to which he turned as a reaction against modern art.

Daimler commissioned this painting as one of a series by different artists and designers. Every purchaser of a car was to be given a reproduction of the picture. Blake explores the conflicting worlds of adult and child in the surreal contrast between the sleek powerful car and the diminutive girl children or fairies. As with much advertising that uses young girls to sell products, Blake does not simply juxtapose adult experience and childish innocence, since the children are depicted in an erotically charged way, their veils emphasising their nakedness. At the same

time Blake seems to suggest that a Daimler, like a fairy, is a fantasy object.

Simeon Solomon 1840–1905

67 *Love among the Schoolboys* 1865
Ink on paper with touches of white bodycolour, 24.5 × 35
Private Collection

This is one of a number of drawings on the theme of boyish sexuality and romantic love by Simeon Solomon. Some were drawn to illustrate flagellation and other erotic themes in the writings of Swinburne. This

drawing is thought to have once belonged to Oscar Wilde. It illustrates the intense relationships at a boys' public school, and in particular the bonds between beautiful small boys and older ones. It must be noted that the drawings were intended for the enjoyment of adults, not schoolboys.

Gilbert and George b.1943 and 1942

68 *BERRYBOY* 1984
Photopiece, 181 × 151
Private Collection

Gilbert and George have always been interested in our perceptions of nature and the natural. Since the 1970s their photopieces have contained images of trees, plants and flowers, often, as in BERRYBOY, combined with images of young men and boys. However, these images are placed in a resolutely urban context; they are ironised by views of decaying townscapes, the besuited figures of Gilbert and George, the boys themselves, who are cool city toughs, and by the use of unnatural heraldic colours. In their 1989 giant assemblages of postcards – 'worlds' or 'windows' as they call them – a central image of a good-looking pop star or actor is surrounded by a myriad of lurid sunsets or mountain views.

In BERRYBOY this 'pin-up' element is strongly present; the beautiful boy, like the berries, is ripe for plucking. At the same time the picture's stained glass window format and colours give the impression of an icon, of a young saint as well as a sex object whose halo is formed by the brilliantly multi-coloured berries. We, and by implication the artists, though they do not appear in this picture, look up at his glowingly youthful face in an attitude of admiration and worship. Gilbert and George, like many Victorian artists, claim that their work aims for the moral betterment of mankind: 'We try to reach, to find a soul or kind of God that is beyond our art.'

1. *Gilbert and George: The Complete Pictures 1971–85*, 1986, xx.

Select Bibliography

Michael Anderson, *Approaches to the History of the Western Family 1500–1914*, 1980.

Philippe Ariès, *Centuries of Childhood*, 1962.

Frederick Antal, *Hogarth and his Place in European Art*, 1962.

John Barrell, *The Dark Side of the Landscape: The Rural Poor in English Painting 1730–1840*, Cambridge, 1980.

Susan P. Casteras, *The Substance and the Shadow: Images of Victorian Womanhood*, New Haven, 1982.

Susan P. Casteras, *Victorian Childhood: Paintings selected from the Forbes Collection*, New York, 1986.

Emmanuel Cooper, *The Life and Work of H.S. Tuke*, 1987.

Peter Coveney, *Poor Monkey: The Child in Literature*, 1957.

Hugh Cunningham, *The Children of the Poor: Representations of Childhood since the 17th Century*, Oxford, 1991.

J-L. Flandrin, *Families in Former Times*, Cambridge, 1979.

Madge Garland, *The Changing Face of Childhood*, 1963.

L. Gent, N. Llewellyn, eds., *Renaissance Bodies*, 1990.

Jonathan Goldberg, 'Fatherly Authority: The Politics of Stuart Family Images', *Rewriting the Renaissance*, ed., M. Ferguson, M. Quilligan, N. Vickers, Chicago, 1986.

Deborah Gorham, *The Victorian Girl and the Feminine Ideal*, 1982.

Hilda Orchardson Gray, *The Life of Sir William Quiller Orchardson*, 1930.

Christina Hardyment, *Dream Babies: Childcare from Locke to Spock*, 1983.

Walter E. Houghton, *The Victorian Frame of Mind 1830–1870*, New Haven, 1957.

Ralph A. Houlbrooke, *The English Family, 1450–1700*, 1984.

Ralph A. Houlbrooke, *English Family Life, 1576–1716: An Anthology from Diaries*, Oxford, 1988.

Martin Hoyles ed., *Changing Childhood*, 1979.

Steve Humphries, Joanna Mack, Robert Perks, *A Century of Childhood*, Channel 4, 1990.

Sally Kevill-Davies, *Yesterday's Children: The Antiques and History of Childcare*, 1991.

Alan MacFarlane, *The Origins of English Individualism*, 1978.

Lloyd deMause ed., *The History of Childhood*, 1976.

Toril Moi ed., *The Kristeva Reader*, 1986.

Ivy Pinchbeck, Margaret Hewitt, *Children in English Society*, 2 vols., 1969, 1973.

Marcia Pointon, *Mulready 1786–1863*, 1986.

Linda A Pollock, *Forgotten Children: Parent-Child Relations from 1500 to 1900*, Cambridge, 1983.
Lionel Rose, *The Erosion of Childhood*, 1991.
Robert Rosenblum, *The Romantic Child: from Runge to Sendak*, 1988.
Simon Schama, *The Embarrassment of Riches: An Interpretation of Dutch Culture in the Golden Age*, 1987.
Gill Saunders, *The Nude: A New Perspective*, 1989.
Desmond Shawe Taylor, *The Georgians: Eighteenth Century Portraiture and Society*, 1990.
Edward Shorter, *The Making of the Modern Family*, 1976.
Carolyn Steedman, *Childhood, Culture and Class in Britain 1860–1931*, 1990.
Lawrence Stone, *The Family, Sex and Marriage*, 1977.
Colin and Tim Ward, *Images of Childhood in Old Photographs*, 1991.
Marina Warner, *Alone of All Her Sex*, 1976.
Christopher Wood, *Victorian Panorama: Paintings of Victorian Life*, 1976.

Exhibition Catalogues

The Age of Innocence? Children in Art 1870–1930, Caroline Simon, Susan Bourne eds., Lancaster and tour, 1989.
Childhood, Sotheby's, 1988.
Childhood in Seventeenth-Century Scotland, Scottish Portrait Gallery, 1976.
The Cranbrook Colony, Andrew Greg, Wolverhampton Art Gallery, 1977.
The Edwardian Era, Barbican Art Gallery, 1988.
Hard Times: Social Realism in Victorian Art, Julian Treuherz ed., Manchester City Art Gallery, 1987.
Mothers, Angela Kingston ed., Ikon Gallery, 1990.
The Pre-Raphaelites, Tate Gallery, 1984.
The Raj, National Portrait Gallery, 1990.
Solomon – a Family of Painters, Geffrye Museum, 1985.
When We Were Young: Children and Childhood in British Art 1880–1989, City Art Centre Edinburgh, 1989.

Index of Artists

Lenders to the Exhibition

*Photographic acknowledgements are due to lenders and also the following (by catalogue number): Bridgeman Art Library: 11, 37, 38; Christie's Colour Library: illus. p. 14; Courtauld Institute of Art: illus. p. 11, illus. p. 46, illus. p. 47 (top), illus. p. 64 (main pic.); Prudence Cuming Associates: 9, 12, 61; Paul Mellon Centre for Studies in British Art: 21.